True Richmond Stories

True Richmond Stories

Historic Tales from Virginia's Capital

Harry Kollatz Jr.

Charleston London

History
PRESS

Published by The History Press
Charleston, SC 29403
www.historypress.net

Front cover image: Around 1868, civil engineer Charles Henry Dimmock designed the Hollywood Cemetery pyramid. Perhaps it looked easy enough on paper, but finishing it with granite stones was another matter. *Courtesy of the Valentine Richmond History Center.*
Back cover image: Richmond's past, present and future were captured by photographer Tim Ashman circa 1997: the derelict *El Toro* tugboat alongside the then-disused James River Kanawha Canal underneath a rushing freight train. Nearby, the former factories of Tobacco Row that throughout the 1990s and early 2000s underwent successful conversion for residences, restaurants and retail. *Courtesy of Tim Ashman.*

First published 2007

Manufactured in the United Kingdom

ISBN 978.1.59629.268.0

Library of Congress Cataloging-in-Publication Data

Kollatz, Harry.
 True Richmond stories : historic tales from Virginia's capital / Harry Kollatz, Jr.
 p. cm.
 Articles which originally appeared in a local history column in Richmond magazine.
 ISBN 978-1-59629-268-0 (alk. paper)
 1. Richmond (Va.)--History. 2. Richmond (Va.)--Biography. 3. Richmond (Va.)--Anecdotes.
I. Title.
 F234.R557K65 2007
 975.5'23--dc22
 2007021395

Notice: The information in this book is true and complete to the best of our knowledge. It is offered without guarantee on the part of the author or The History Press. The author and The History Press disclaim all liability in connection with the use of this book.

For Amie O., My Grande Louvre,
who married me, Richmond and the
Firehouse Theatre Project, and has
somehow maintained her love for all
three. All within is the past, but
we are just beginning.

and

For Ed, Lorena and Sharon: who knew that
Edsels would get us this far?

I would rather die in Richmond somehow, though God knows Richmond has little enough to offer. But in Richmond, or in any Southern city for that matter, you do see types now and then which depart from the norm. The South is full of eccentric characters, it still fosters individuality.

Henry Miller, *The Air-Conditioned Nightmare* (1939)

Contents

CONTENTS

Foreword

Observant Richmonders, if they know what they are looking for, will often spy loping along West Broad near the Science Museum or through one of those pleasantly bosky streets of the Fan a tall figure wearing one of those hats I believe were, in their day, known as fedoras. The man walks with a purpose, but it cannot be said that he is lost in thought. He seems to know something interesting about most houses he passes and surely each statue. To walk with him, for he is a talkative fellow, is an education in his city's present and past. A little of what he knows makes it into the "Flashback" column he writes for *Richmond Magazine*, but there is a lot that does not. One hopes he finds room for it in columns to come.

This somewhat enigmatic, even romantic figure, is Harry Kollatz Jr., who may be more of a treasure than his engagingly rambling column, though it is nothing to sneeze at, either. Kollatz is not only a writer and historian. He is also an actor, a director and an impresario, as well as a pretty fair raconteur. To read one of his columns is to know what it is to go on long walks with him when, coming upon some abandoned warehouse, he stops to tell you what went on there in, oh, 1913. He knows what occurred in grand old houses on Monument Avenue but also on empty lots in Oregon Hill. How he knows these things is anybody's guess, but I am glad he does.

The column is chockablock with oddments and served up, thankfully, without the snarky "Weird America" facetiousness that afflicts so much journalistic writing these days. Kollatz is not solemn, and he does not lack a sense of humor and even a sense of the absurd. But he treats his subjects, no matter how outlandish, with respect. He can also write well about serious matters, as he does in his essay, printed herein, about the actor Charles Sidney Gilpin.

FOREWORD

My personal favorite—and one that seems somehow representative of the whole—concerns Lady Wonder, the Chesterfield County horse of the 1920s. For fifty cents, Lady Wonder would answer questions on a device Harry describes as "a piano-size, scrap-metal typewriter mounted on two rusty jacks that used a double row of keys topped by sponge rubber. When Lady nudged a key with her nose, a bracket was released, and a tin card popped up bearing a letter or number."

Lady Wonder predicted the outcome of ballgames and elections, advised the lovelorn and helped baffled police detectives solve cases. A Duke University psychologist came up from Raleigh to investigate the horse's alleged powers and determined that she could spell such words as Mesopotamia and Hindustan, a feat which would make her a marvel not only among horses but also among most American high school students, Standards of Learning or no.

I do not wish to make too much of the connection, but Harry Kollatz is something of a phenomenon as well, and you will enjoy the reportage that follows. I know I did. We know what happened to Lady Wonder (she died, Harry says, on March 19, 1957), but we do not know what happened to the contraption on which she composed her answers. I like to think Harry keeps it in his attic and used it to write these columns. If so, it might explain Harry's own remarkable gifts. Enjoy!

Allan Pell Crawford
Author

Preface

The "Flashback" column premiered in 1993 as a small rear-guard defense against encroaching oblivion. One of the frustrations in writing about the city's history is that the present and its often short-sighted demands are eating away at the vital past.

Most times, magazine columns aren't enough. Such was the case in September 1995, when the Capitol Theater, at 2525 West Broad Street, was with almost cruel zeal (and little cause) ripped to pieces. The Fan District and West Grace Street Associations tried halting the sudden demolition because the apparent intention was to install a McDonald's with a drive-through window on the busy corner of Robinson and Broad. The neighborhood groups chased Mickey D's down the street, but it couldn't forestall the Capitol's destruction. When I got to write about it in December 1995, it was as if the place never existed. The lot, to this day, remains scruffy grass that collects wind-blown trash.

The Capitol Theater was built in 1926. Richmond Italian American sculptor and plaster artist Feruccio Legnaioli created the Richmond region's first "atmospheric" theater décor. The auditorium simulated a Spanish garden, complete with draping greenery, urns, iron gates and statue niches. This interior didn't survive successive "remuddlings" during the 1930s and 1960s. The Capitol was the first in the South and the sixth in the nation to possess Movietone synchronized sound equipment. *The Jazz Singer*, the first talkie, premiered in Virginia at the Capitol. A generation later Richmond movie impresario Ray Bentley started all-night movie jams there. People saw for the first time at the Capitol *M*A*S*H*, *The Exorcist*, *Lenny* and *Silver Streak*.

The theater anchored a block of diversion across from the bustling Broad Street Station; the row included the Byrd Hotel and Julian's Restaurant.

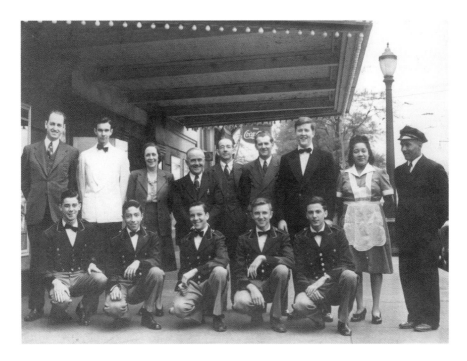

The staff of the Capitol Theater during its heyday. *Courtesy of John Wirt.*

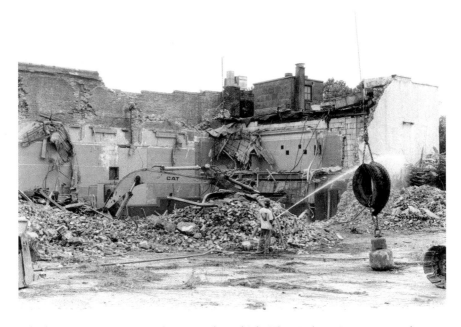

Whether or not Dean Martin's Matt Helm vehicle *The Wrecking Crew* was ever shown at the Capitol, the non-cinematic variety arrived with a vengeance in 1995. *Author's collection.*

Broad Street Station closed, ending the usefulness of the nearby William Byrd Hotel and reducing the patronage of next-door Julian's Restaurant. The property owner wanted to cobble these properties into a convention center, but that scheme fell through. The Byrd became a retirement center, Julian's moved up the street (and then away) and the Capitol was leveled. I took pictures.

Had the theater stood a few years more, the Richmond Moving Image Co-op or community performing arts group could've used it. When a building is taken down, we deny ourselves of what was and what might yet be.

Richmond is a curious and flabbergasting place. Perhaps "Flashback" followers can get their bearings about the region's past to better understand that we, Richmond, are a story unto ourselves—beyond the Civil War.

On purpose, not many columns were devoted to that conflict. Like asphalt in Richmond, it's already everywhere. During the past fifteen years, just two pieces were devoted to that conflict, and one is included here. There's plenty else to write about beyond booted and bearded men on rearing horses.

But, in honesty, I'm less the expert and more a sleuth. Abundant clues have been provided by the ever-helpful Teresa Roane, former archives director of the Valentine Museum, and her successor, the wonderful Meghan Glass; artist Richard Bland; those crazy kids at the Literature and History Desk of the Richmond Public Library who administer the clip files that bash down brick walls when I run into them; the magnificent architectural archives at Virginia's Department of Historic Resources and the Library of Virginia's collections; historians Robert Winthrop, Calder Loth, Christopher Silver, Michael Chesson, Mark Greenough, Gregg Kimball, Helen Rountree, Ed Slipek Jr., Marie Tyler-McGraw and Jeffery Ruggles; and the late and lamented *Virginia Cavalcade*. (For shame that it was halted!)

Thus, this little book required a big group of people to come into fruition. You never quite understand that until you're in the mix of it. From those who lived the stories recorded herein to scores of museum, archive and library professionals who've guided me in my assorted expeditions, and to the varied editors who helped shape and mold the text so readers wouldn't find themselves immersed in an unpalatable word salad, then at the end of all this, one day in December 2006 when Lee Handford of The History Press called *Richmond Magazine* Managing Director Susan Winiecki and asked her if anybody there wrote about Richmond history.

You're holding the response.

Frances Helms green-lighted "Flashback" in 1993 and Susan shepherded the column through front to back to front migration, expansions and contractions and with patience contends with the churlish writer. Through

the years a cohort of editors—Richard Foster, Chad Anderson and Jack Cooksey—have needed to tell me the piece was too long, or just didn't make sense, and both are often the case. But without publishers Rich and Lisa Malkman, in truth, these pieces of memory wouldn't exist. *Richmond Magazine* intern Whitney Proffitt transcribed from actual wrinkly paper a slew of pre-1998 columns not stored in an accessible computer memory. This proves that you can't yet Google everything, and perhaps some comfort can be taken in that you still need to sift through crinkled pages and dusty tomes to get the real details. The entire art team of the magazine, at one time or another, helped ferret out images and process them for publication: Steve Hedberg, Isaac Harrell, Lee Aulick, Justin Vaughan, Jimmy Dickinson and Mike Freeman.

On a personal note, the combination that brought me into the world, Ed and Lorena Kollatz, gave me the appreciation for reading and history that put me on the path toward this book. Who knew that the Edsel would possess muse-like qualities? Another component to my personal journey with history was the Lloyd C. Bird High School Civil War Club, including Mike Davis, Robert Short, Norman McLean, John Zilius and our inspiration and teacher, Steve Cormier. But most important, my Amie, to whom this slender volume is dedicated. Look, sweetheart, how all those late hours have been made manifest.

In addition, my practice of writing history was established in the *Richmond Review* (1987-90), edited by Jim Armstrong and Michael Neal, who in essence gave me my first shot at it on real newsprint that yellows.

I doff my fedora to wingman Jason Smith and David B. Robinson, CPA, both of whom kept nagging me to do this thing; the Firehouse Theatre Project gang, who've endured plenty of my ramblings; and Demetrios Tsiptsis at the revived New York Deli, who keeps the Legend cold for me and shares the fever for history.

And a big group shout out goes to Messrs. Mordecai, Cate, Valentine, Christian, Troubetzkoy, Freeman and Dabney. You guys are always there for me. Thanks.

Much of this material first appeared as a monthly column in *Richmond Surroundings* or *Richmond Magazine*, from 1993 to 2007. By arrangement, the author retained rights for this publication by The History Press.

The images in this book, unless otherwise noted, are from the collections of the Valentine Richmond History Center and are used with their permission.

Introduction

How do you tell the history of a city? For the Valentine Richmond History Center, we tell it through our exhibitions, programs and tours. For Harry Kollatz, it is the perfectly told story of the people and events that have shaped the life of our city. Through his work in theater and his writing, Harry brings to life both our tragic and inspiring moments with an amazing sense of irony and humor. Accounts of those odd moments and unusual occasions from the past push us beyond our usual understanding.

Through Harry's writing, we are given a glimpse of a much more human and colorful story. He fills our historic streets and architectural treasures with the spirit of the people and their ideas that still inhabit them today. This collection of stories reflects our history's challenges and promise.

Harry is a great partner with the Valentine Richmond History Center as we challenge our region to take a fresh look at the history that surrounds us. It takes an imagination like Harry's to weave together the over one million images in our archives and half million objects in our collections.

Harry Kollatz loves Richmond. He loves its history, its art and theater, its architecture and its people. And I know that you will love these stories.

Bill Martin
Director
Valentine Richmond History Center

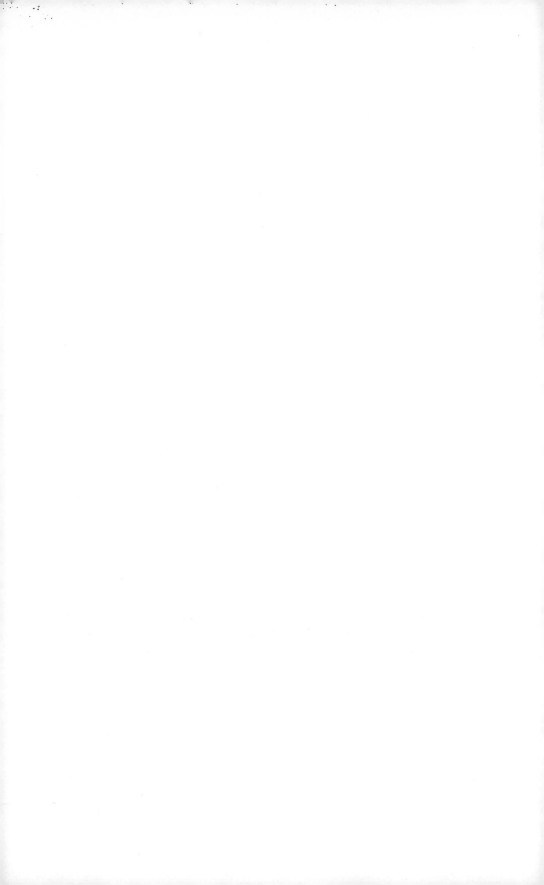

Finding the Founding
Newport's Cross

It was one of the first big lies the English settlers told the native Powhatan people. The cross planted on a small island on the afternoon of May 24, 1607, near the falls of the James by Captain Christopher Newport entered legend almost as soon as the one-armed commodore shoved it into the ground.

Newport told the wary Powhatan that it symbolized the forging of a bond between his people and theirs. Never mind that the wood planks bore the crude legend "Jacobus Rex, 1607" for King James. Newport represented the leading edge of British expansion. The English on that afternoon were, as they perceived the situation, one step ahead of the cruel and hated papist Spanish.*

The night before, the "adventurers" were accorded hospitality through rituals of tobacco smoking, feasting and dance. The English expeditionary force, just a week after beginning construction of James Fort (Jamestown), met with the original residents in a hilltop village called Powhatan, perhaps on the site of today's Tree Hill Farm, just across the Richmond limits in eastern Henrico. The site may have also been the birthplace of the region's paramount chieftain, Powhatan. The place was administered by Parahunt, one of Powhatan's many sons.

During evening entertainment illuminated by flickering fires, the English prodded their hosts about what was upriver and the distance to the mountains. Parahunt wasn't keen to answer and he avoided the subject. The river coursed through the territory of the often-hostile Monacan tribe, into a mountainous country called Quirank. Beyond it was what the English sought to interpret as a large body of water—the Indian Ocean. On May 24, 1607, after lunch provided by their hosts, Parahunt and a guide, Nauiraus, led Newport and company to the falls.

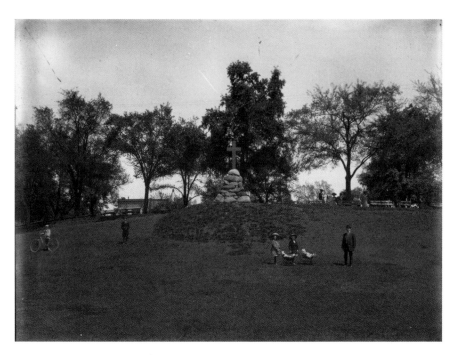

Christopher Newport Cross at Gamble's Hill Park. The park, for decades a favorite place for downtown strolls, would be swapped out and the cross moved twice during the twentieth century. *Courtesy of the Cook Collection, Valentine Richmond History Center.*

The group's historian, Gabriel Archer, recalled the river as "full of huge rocks." He saw a large island about a mile away and alongside the river "high hills which increase in height one above another as far as we saw." The dramatic site overlooking rocks and rapids was near the north end of the present Mayo's or Fourteenth Street Bridge and occupied by the Southern Railway freight building. This is where First Market Bank headquarters and Morton's Steakhouse are situated, near the Canal Walk's turning basin.

The Powhatan tried dissuading the English from further travel. In *A Relation of Discovery*, attributed to Archer, the writer describes "sitting upon the bank by the overfall, beholding the same" while their native guide, Nauiraus, with Parahunt at his side, began describing "the tedious travel" to be faced if the explorers continued. The village of the Monacan, enemies of Parahunt, was a day and a half away. It seemed best not to rile the Monacan with strange white faces whom the Powhatan's enemies would assume were sent by Parahunt. Besides, journeying to Quirank would exhaust them and they'd have trouble securing food for such a long journey.

The English were eager to push on. Newport, acting diplomat, heeded Parahunt's advice. But he wanted to indicate the company's westernmost

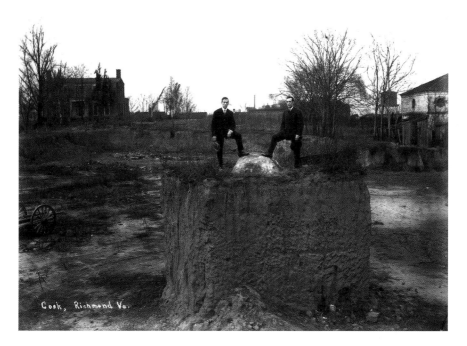

The Powhatan Rock is at the abandoned eighteenth-century seat of the Mayo family located on bluffs just outside Richmond, in Henrico County's Varina District. Five generations of Mayos lived there from 1726 to 1865. Mayo tradition became Richmond folklore that credited the stone as marking Chief Powhatan's burial site. It rests now upon the brow of Chimborazo Hill. This image was made in 1906, the year before the stone's guest appearance at the Jamestown Exposition that commemorated the three hundredth anniversary of Virginia's settlement. *Courtesy of the Cook Collection, Valentine Richmond History Center.*

advance. Newport placed the simple wood cross with the king's name above and his below. Parahunt well enough understood the symbolism, and angered, he left. Newport explained to those who remained, through Nauiraus, that the cross meant union, not domination.

The party then gave a shout of celebration while the Powhatan looked on. After this ceremony, the English found Parahunt, calmed him and the duped native prince gave them a kind farewell. As the explorers pulled away in their boat, both native and newcomer gave parting cries of friendship.

On June 10, 1907, the Association for the Preservation of Virginia Antiquities dedicated a copper cross upon a pyramid of James River granite on Gamble's Hill at the base of Fourth Street. At that time, it seemed to overlook the general place where Newport had placed his cross.

Judge David C. Richardson, a future Richmond mayor, on the warm, drizzly afternoon said, "From the time when Jacob erected a pillar at Bethel

down to the present day, it has been the custom of nations and peoples to mark the spots at which important events have occurred by some enduring memorial."

The Gamble's Hill site became a tourist attraction and favorite promenading spot, for the view of the rapids, the industrial might of Tredegar Iron Works and the whimsical turreted and crenellated Pratt's Castle, made of rolled sheet iron, scored and painted to resemble the stones upon which it sat.

In 1983, after a land swap with Ethyl Corporation, the memorial was removed to Shockoe behind the Martin Agency nearer the probable site. The peripatetic pile and cross were moved once again in 2003 to the bottom of Twelfth Street along the canal walk, even closer to the actual location.

Originally published 2003–07.

*And, in fact, all this happened somewhat later than is noted in most accounts because of the then-ten-day difference between the "Old Style" (Julian) calendar used in England until 1752, and the "New Style" (Gregorian) calendar used ever since. Not to make waves, this book uses the standard dates. Just thought you'd like to know.

You Say You Want a Revolution
British Come, Jefferson Flees

During the chilly late afternoon of January 5, 1781, Virginia Governor Thomas Jefferson stood helpless at his vantage point in Manchester as he watched warehouses and workshops in Richmond burn. Traitorous General Benedict Arnold, who hadn't received a satisfactory response to his demand for the surrender of the one-year-old capital of Virginia, was torching the town.

About a month before, on December 9, 1780, General George Washington himself had warned Jefferson that a fleet of British troopships had left New York City, bound southward. Jefferson first heard of twenty-seven vessels entering Chesapeake Bay on New Year's Eve morning. He thought that the French might at last be coming to the bogged Revolution's rescue. However, by dawn on Thursday, January 4, 1781, Jefferson understood that the British were coming to Richmond. He sent his wife and daughters away and oversaw the transportation of fifteen tons of gunpowder and military stores out of town.

Benedict Arnold had managed to land infantry, dragoons and light artillery at Westover Plantation, the ancestral estate of Richmond's founding Byrd family, thirty miles from the capital, with nary a defensive shot fired. Arnold and his green-coated "American Legion," made up of mercenaries and Continental army deserters, arrived in Richmond by 11:00 a.m. on January 5.

A mere two hundred hardscrabble Virginia militiamen assembled. Many of them weren't armed. Colonel John Graves Simcoe of the Queen's Rangers sent dismounted soldiers up Church Hill to disperse the militia. The Virginians managed to fire one ragged volley before scattering into the woods, pursued by the British.

The Governor's House was a rented place near the southeast corner of today's Capitol Square. When the British came to call they found Governor

Jefferson not at home. Arnold's men ransacked the house and cracked open his Madeira casks when the servants wouldn't reveal where the governor had gone. Jefferson also would not respond to an ultimatum: "Give me the tobacco stores," Arnold had declared in a letter, "and I'll not harm the town." The governor didn't negotiate with turncoats.

Arnold then commenced to stealing the tobacco and ordered the selective burning of structures, though he passed by the Virginia General Assembly building, a makeshift commercial structure at Fourteenth and Cary Streets. Simcoe's dragoons destroyed the Westham foundry. Many wartime Virginia documents were lost to fire, including Jefferson's letters.

Arnold and Simcoe met that Friday evening at Gabriel Galt's tavern on the northeast corner of Nineteenth and Main Streets (now an open-air performance space associated with a restaurant). Where Jefferson spent that terrible evening isn't known; Manchester tradition maintains that he hid in a house owned by his relatives, possibly in the attic. Jefferson never said.

By noon that Saturday, Arnold had left the smoking city for Westover. Following him were numerous escaping slaves.

Through spring 1781, British Generals William Phillips and Lord Charles Cornwallis again attacked and burned buildings in Manchester and Richmond, causing Jefferson and the state legislature to refuge to Charlottesville in late May. Several days later, militiaman Captain Jack Jouett happened to be in a tavern outside Richmond when he glimpsed Colonel Banastre Tarleton's raiders in pursuit of Jefferson. Jouett rode hell-for-leather to Charlottesville to alert the Virginia leadership. Jefferson was saved and Monticello somehow spared.

Jefferson stepped down as governor that summer. The French showed up and none too soon. The British surrendered at Yorktown on October 19, 1781. "Quitting office so close to the end of the Revolution only heightened Jefferson's humiliation" over being forced to flee and having his courage impugned, writes biographer Willard Sterne Randall.

Jefferson was criticized by members of the General Assembly for "pusillanimous conduct" in fleeing the British invasion of Richmond. Hanover County state representatives George Nicholas and Patrick Henry questioned when Jefferson knew the British were coming and why he failed to take swift and decisive action to stop them.

Jefferson testified for two days in December 1781 before the Virginia legislature that in the end held a unanimous vote to absolve him. Jefferson never forgave Henry.

Of his war governor period, Jefferson's great biographer Dumas Malone remarked, "To say that [Jefferson] was a misfit as an executive would be to

say too much. But there were other tasks he liked to do, and did, a great deal better."

Originally published July 2004.

Update: A mock-up of the façade of the Virginia General Assembly's temporary meeting hall overlooks a parking lot at Fourteenth and Cary Streets. Here in 1786, the legislature adopted Jefferson's Virginia Statute for Religious Freedom that established as a cornerstone of U.S. democracy that all people may worship, or not, as they choose, and without interference or adherence to a state-sanctioned faith. The site is to become a part of the First Freedom Center that is an ongoing project of the nonprofit Council for America's First Freedom.

First Market
Shopping at Seventeenth Street

The Virginia General Assembly established the "publick market" in 1779 as part of the state capital's transfer from Williamsburg to Richmond. The legislative act also selected sites for the capitol, Halls of Justice and the governor's residence. At the time, Seventeenth Street was known as First Street.

In 1792, "an open shed supported on wooden posts" occupied a site at First Street, east of what was Shockoe Creek, recalled Samuel Mordecai in his 1859 book *Richmond In By-Gone Days*. The slope down to Shockoe Creek "was a green pasture and considered a common, much used by laundresses whereon to dry their clothes which they washed in the stream." This common on the south side of Main Street held a spring that later served a tavern built there.

Main Street was a country road wending between Williamsburg and Richmond, placing the market at an important intersection. Shockoe Creek was navigable by small oyster boats, and the market was the natural pivot of commerce.

Near present-day Seventeenth and Franklin was "The Cage," an octagonal structure—the city's first lockup—with attendant whipping post. The market was enlarged in 1812 and 1828, and other activities were centered there beside the jostling of market carts and the hucksters' cries of melons, greens, herbs or fish. A famous market shopper was Chief Justice John Marshall. He was a casual dresser at a time when fastidiousness was the rule. Once at the market, a man who'd bought a turkey mistook Marshall for an errand runner and offered him a coin if he would carry the turkey up the hill for him. Marshall, then head of the U.S. Supreme Court, accepted. Versions conflict as to whether he took the gratuity or, with characteristic humor, declined.

First Market

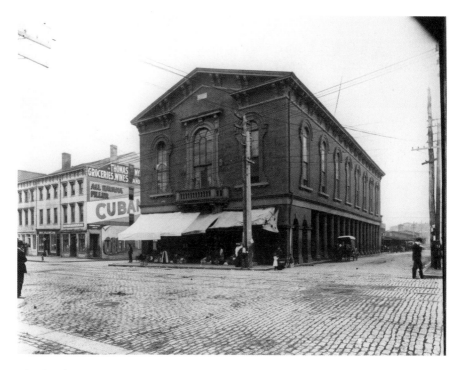

This handsome structure served multiple civic purposes in addition to housing the First Market, 1854–1912. The market house was the center of the 1870 Municipal War. *Courtesy of the Cook Collection, Valentine Richmond History Center.*

Around the market prior to the Civil War, slave auctions and sales were conducted. Lumpkin's Jail at Fifteenth and Franklin Streets was constructed to hold slaves before they were sold off. In 1867 Dr. Nathaniel Colver, a feisty grandfather, met Mary Ann Lumpkin, a former slave whose deceased husband Robert Lumpkin had earned his wealth from the slave trade. She rented the former jail to Colver, and there he founded what evolved into Virginia Union University.

A market building was completed in 1854. During the bulk of fifty-eight years, it bustled as a vital component of the city's commerce and government. Meats were sold on the first floor. The second floor included a police station, courtroom, community meeting room and a bell that rang the time to Main Street passersby. The market building was used for religious revivals, and during elections candidates encouraged votes with barrels of whiskey.

The market's important civic function placed it in a featured role during the 1870 civic unrest caused by the refusal of the Reconstruction-era mayor to leave office. The grand old market was demolished in 1912 for a far less interesting structure.

Meat was the market's principle product, although plenty else was available. A fish stand was located in another market building along Seventeenth and Grace Streets. Carts were parked along East Franklin and Eighteenth, bearing fresh produce that was often simply strewn along the cobbles for inspection. In 1927, flooding from Shockoe Creek was tamed by the market's concrete and brick walls. Merchants' complaints of ceiling paint chips fluttering like snow onto their displays resulted in $10,000 worth of repairs in 1943.

Saturday was the big family marketing day. The larder could be replenished with cracklings for corn bread, chitterlings, fatback, sausage or pepper-coated Smithfield hams. The array of fruits included Virginia apples, California grapes, pears from Oregon and Costa Rican bananas.

The city government maintained a market commission but the farmers market was in time placed under the jurisdiction of the city's parks and recreation department. This move caused a certain sense of abandonment by the growers and sellers. Throughout the next thirty years, the market's viability was assaulted by large indoor grocery stores and the decline of small farmers. The market was razed in 1961 to accommodate parking and traffic snarls. A series of sheds and stands replaced the old building and it seemed the market was finished.

Various plans sought to relocate it to the Main Street Station or the state fairgrounds. The Shockoe Bottom renaissance of the 1980s instead brought new life to the market. Some shoppers, weary of fluorescent lighting, chemicals and sameness, got hungry not just for fresh eggplant but also for an authentic experience and good product at a reasonable price. A round of renovations soon followed.

In 1995, a seven-member Farmers' Market Commission was formed by the city to implement the next phase of the market's history. Chris Scott, owner of None Such Place and Homer's Real Sports Grill in Shockoe Bottom, was its chairman.

"Basically, we were asked by the city if we wanted to run it or should it just be let go," says Scott, a native Richmonder. "But it's too valuable to allow that." A New York–based consulting firm recommended a $160,000 budget and expected the market could turn a $17,000 profit in three years. City council provided an initial budget of $127,000 to hire a manager and make physical improvements.

"Our objective is to be self-sufficient in five years; we hope in three," Scott says. In other cities, markets have brought up surrounding neighborhoods, while in Shockoe, the time has come to have the historical market diversify the district's offerings.

First Market

Current plans call for not only daily produce offerings but also a nighttime arts and crafts market and a Sunday antiques fair. "We're not talking about a flea market but a well-organized group selling quality items," Scott says.

Originally published November 1997.

Update: One of Richmond's oldest public institutions continues to operate in the twenty-first century. Under the energetic direction (1998–2004) of Kathy Emerson, offerings expanded to year-round events, from Christmas tree sales to the summer Shockoe Tomato Festival. As of 2007, the city is contemplating constructing yet another building for the market. The market is not yet self-sustaining, but through a combination of management and marketing, greater downtown residencies and public/private support, independence remains a possibility.

Mr. Hawkins's Wild Ride
The Sturgeon Breaker

On a splendid day in May 1779, Martin Hawkins used a sturgeon in the eighteenth-century version of an extreme sport. Hawkins, an experienced outdoorsman, was joining scores of shad fishermen among the rocks along the James River when he was surprised by the arrival of an immense sturgeon. Hawkins thought if he was careful, he could get hold of the fish and haul it from the water. He stopped, rubbed his hands along the big fish's flanks and then seized its gills. The startled sturgeon jolted and took off, yanking Hawkins from his rock. The fish headed downriver with Hawkins hanging on.

Onlookers cheered and ran along the banks. The sturgeon, like an unbroken horse, struggled to throw its unbidden passenger, but it grew tired from thrashing, and Hawkins beached the fish just past Mayo's Bridge. He emerged from his ordeal to a great ovation from gathered townspeople.

The catch of the day, or decade, measured ten feet, weighed three hundred pounds and provided the main course for an evening of merriment. Hawkins, afterward known as Martin Hawkins the Sturgeon Rider, lived seventy-three years.

This story was reported in the February 20, 1896 *Richmond Religious Herald* by W.C. Taylor, concerning the ninety-first birthday of Dr. J. Russell Hawkins, a great-nephew of the sturgeon rider. Dr. Hawkins gave a number of recollections in the article and "a finer memory cannot be found," Taylor wrote.

Then again, it could all be a family legend.

Richmond artist Jay Bohannan found the story in Virginius Dabney's history of Richmond and was moved to illustrate the scene. "I was intrigued by the tall-tale aspect of the story," he says, "like Paul Bunyan and Pecos Bill, and also showing the anything-is-possible exuberance of a new nation."

Mr. Hawkins's Wild Ride

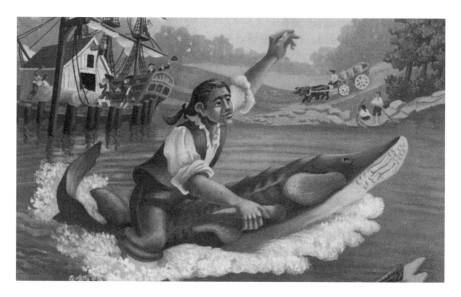

Artist Jay Bohannan's version of the wild ride Martin Hawkins took upon the back of a James River sturgeon in 1779. *Courtesy of James Bohannan.*

The Hawkins yarn is unverifiable. Richmond didn't have a newspaper in 1779, and the *Virginia Gazette* in Williamsburg, filled with war news, has a Martin Hawkins in the classifieds advertising property for sale, but no mention is made of reputed aquatic broncobusting.

Chief Tecumseh Cook of the Pamunkey, eighty-one years old in 1981 when outdoors writer Max Ailor of the *Times-Dispatch* wrote about sturgeons, said sturgeon riding was a rite of passage for native boys. A youth could become a man by the successful riding of the huge fish for a distance down the river. He would climb upon a two- or three-hundred-pound sturgeon, grab its gill plates and go for however long he could maintain his grip.

Captain John Smith, himself a whopping storyteller, wrote that during his expeditions in Virginia, sturgeon were so plentiful they impeded the progress of his small reconnaissance boats. Soldiers could plunge their swords into the fish and lift them in.

During plantation days, sturgeon were captured and chained to bridges and pier pilings to await the proper ripening of the roe. The fish were butchered, the roe were sent to the big house and the meat, thought to be less valuable, was divided among the slaves.

Sturgeon were so plentiful in Richmond during the 1890s that choice steak from the fish sold for no more than ten cents a pound at the city markets. Pollution and dams thinned the numbers of the rare, lumbering creature. Yet around 1920, a man lashed a sturgeon to a strut of the old

Manchester Bridge and called photographers, but by the time they arrived the fish was too tired to perform. On August 16, 1928, J.H. Pace of 1206 North Twenty-first Street landed a 250-pound sturgeon near Mayo's Island. In the newspaper photo, Pace has a big smile and the fish does not.

In April 1942, R.C. Bishop caught a sturgeon while netting for shad in the James near Westover. Bishop's catch was a less robust specimen than Pace's, measuring only fifteen inches. An unidentified *Richmond News Leader* wag suggested the sturgeon had stunted its growth by smoking cigarettes. He explained that sturgeon are prized as a source for caviar, a fancy name for sturgeon eggs. "These are small and dark in color, resembling the B-Bs you used to shoot in your air gun...Some people maintain that you can get the effect of eating caviar by putting on a pair of smoked glasses and eating a dish of tapioca pudding. Anyway, it's cheaper."

Sturgeons of varying size kept bumping into boats and startling fishermen in the James, Appomattox and Chickahominy Rivers throughout the 1950s. On May 11, 1964, Chief Curtis Custalow of the Mattaponi tribe, and his wife, Princess White Feather, struggled with a 169-pound sturgeon carrying 45 pounds of roe. The fish rolled up in his drifting shad net, and Custalow used his experience as a professional wrestler to subdue the giant fish once he got it beside the boat.

James River Parks coordinator Ralph White says that a few years ago a James River rafting instructor spotted a six-footer near the Powhite Bridge and used his paddle to measure the creature. Other sightings and the arrival of eagles, otters and huge catfish point to a cleaner river. Still, the James may never again be clogged with huge sturgeon. But remain attentive while relaxing along the swirling waters. You might not want to emulate Mr. Hawkins's wild ride, even if it would make for one whale of a fish story.

Originally published December 1997.

Morals and Mirth
Latrobe's Downtown Performance Center

A committee of prominent Richmonders wants a performing arts center built amid a central city gasping for life. Wrangling ensues for funding, and rancorous debates within and without the city's newspaper editorial pages question the utility and worthiness of such a building and its ultimate location. The public doesn't want its tax money used.

The time was mid-1960s Richmond, the background a struggle of urban renewal. The theater was based on a design from the late 1790s that wasn't built in Richmond because novice dilettante architect Benjamin Henry Latrobe (1764–1820) couldn't raise the money for the construction. Latrobe's fanciful theater was to be dedicated "To Morals and Mirth."

The English American Latrobe, who would later contribute to the designs of the U.S. Capitol and the White House, arrived in Virginia in 1796 and lived in Richmond until the summer of 1798. His watercolors of late eighteenth-century Richmond are glimpses from the window of a time machine. His biographer, Virginia Commonwealth University art historian Charles Brownell, observes that Latrobe "was rich until his money ran out, and he had to start designing things for a living."

During the fall of 1797, Latrobe got involved with the traveling players of Thomas West, performing in Richmond's inadequate theater building at Twelfth and Broad Streets. Latrobe was inspired. He wrote a play of political satire, *The Apology*, that didn't survive. His drawings for his proposed new Richmond theater did. Latrobe made them between December 2, 1797, and January 8, 1798. The old Richmond Theater curiously burned to the ground without loss of life on January 23, 1798.

West and Latrobe attempted selling stock to build their proposed nine-hundred-seat entertainment center. It was, Brownell says, "avant-garde Neoclassicism at its best. Because he was inexperienced, Latrobe tried

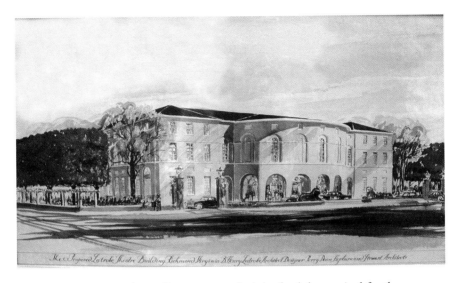

It would have been Richmond's stage center had the funds been raised for the construction of this theater designed by Benjamin Latrobe. The building was proposed in 1798 and 1964. *Courtesy of the Valentine Richmond History Center.*

putting everything he knew into one building, and he didn't know quite how to make it work." This included a cantilevered ceiling that would have squashed the high-dollar balcony seats, leaving them with just three feet of headroom. The top-hat-and-silk-finery crowd would have had to crawl to be seated.

Latrobe envisioned a Palladian design featuring a tremendous bowed front that echoed the shape of the interior stage. The building's amenities were to include carpentry shops, dressing rooms, elegant chambers, coffee rooms, dance halls, a shopping arcade and lodging. It was an unaffordable late eighteenth-century convention and visitors' center for Richmond, which was then officially fifteen years old, with a population of roughly five thousand.

West and Latrobe parted. A new Richmond Theater was instead constructed—and not very well—in 1804. Its December 26, 1811 destruction by fire, with the loss of seventy-five lives, seared into Richmond's consciousness the proof of theater's evils—though not the evils of unsafe buildings.

The Latrobe revival of 1964 sparked stormy meetings and large newspaper articles weighing the merits and demerits of the project. The plan's promoters included socialite Banny Bosher, preservationist Elisabeth Scott Bocock, real estate developer Joseph Stettinius and future Tobacco Row developer William H. Abeloff. Press conferences were held, models displayed and funds solicited.

Morals and Mirth

The proposed theater would have provided three thousand square feet apiece for four arts organizations and six thousand square feet for a repertory theater company. The estimated cost was $2 million. The eventually chosen site was between Eighth and Ninth Streets at Clay and Leigh Streets—an area that remains a parking lot to this day. In the end, Mrs. Bosher's death and an apparent lack of public enthusiasm shelved Latrobe's erstwhile plans.

Throughout the 1970s and 1980s, various organizations tried to make midtown merry. This ranged from June Jubilee, which brought thousands of visitors downtown for arts and entertainment, to fine arts and performance exhibitions in city alleyways orchestrated by the gypsy United Artists Amalgamated.

In 1986, Theatre IV acquired and restored the former Empire/Maggie Walker Theater. The nonprofit company, founded in 1975, has since expanded to include the Barksdale Theater at Willow Lawn and the stage at historic Hanover Tavern, where the Barksdale originated.

Another group during the 1980s tried linking the Masonic Temple at Adams and Broad with Theatre IV and the Hippodrome in Jackson Ward (today undergoing renovations). That alliance collapsed, due in no small part to the city's 1985 creation of the ill-starred Sixth Street Festival Marketplace.

Midtown Richmond enters its fourth century awaiting the arrival of Morals and Mirth.

Originally published September 2003.

Update: Throughout the 1980s and 1990s art exhibition spaces moved onto Broad Street, in part to escape rising Shockoe rents. These included the pioneering 1708 Gallery and the cooperative-run Artspace. Creative Culture's First Fridays Art Walk was conceived in 2000 by an Artspace committee led by then-executive director Christina Newton. She formed Creative Culture in 2003 to further harness the power of the visual and performing arts. Each month for this event more than five thousand people flock into Broad and its tributary streets.

Meanwhile, after much to-and-froing, the Virginia Performing Arts Foundation, inaugurated in 2001, rechristened its midtown project in 2007 as Richmond CenterStage and changed the Carpenter Center for the Performing Arts (the 1929 Loew's movie palace that in 1983 underwent its first transformation) into the Carpenter Theatre. The effort also entails the refurbishing of the 1927 Landmark Theatre (née Mosque Auditorium). CenterStage is to include a two-hundred-seat black box performance space

and a multipurpose hall. Of the projected $65 million for the undertaking, $25 million is coming from city coffers. Completion is slated for 2009.

Before then, it appears that two performance venues backed in their entirety by private monies, and adapting rescued-from-demolition buildings, are to be in full swing. These are the 1923 National Theater, the remaining grande dame from Broad Street's Theater Row, and the 1896 Lady Byrd Hat Factory. The National team's guiding inspiration and partial management comes from the successful Norva concert venue in Norfolk, Virginia. The Lady Byrd is a Richmond-run extension of the famed New Haven, Connecticut Toad's Place.

These venues will feature nosh-to-mosh restaurants, connections to national-level talent and the capacity to shake Richmond from its doldrums and bring, if not morals, then at least mirth.

Before Art after Hours
The First Virginia Museum

Richmond *Enquirer* editor Thomas Ritchie in 1815 issued the exuberant call for a "Museum in the Metropolis of Richmond." The moment seemed full of possibilities: the War of 1812 was won, and the economy was growing at a dizzying pace.

Into this excitement entered two entrepreneurial artists: entertainer-turned-painter James Warrell and Petersburg miniaturist Robert Lorton, the brother of Warrell's first wife. The two raised $10,000, drawing their own money and that of subscribers to create a museum on Capitol Square.

Warrell planned for a winged neoclassical brick structure, including an English basement, a two-story center section surmounted by a cupola to light the Hall of Paintings, an arch to pass through the building to Capitol Square and gas lamps for special evening programs.

Governor Wilson Cary Nicholas, U.S. Supreme Court Chief Justice John Marshall and Ritchie signed Warrell's petition to the Virginia General Assembly in December 1815 for "erecting a handsome edifice" on the east side of the square, facing F (later Franklin) Street. In February 1816, the legislature approved the request.

The arts partners Warrell and Lorton solicited the public for statues, paintings, wax figures, engravings, petrifactions (fossils), Indian artifacts, birds, serpents and shells as plans proceeded for the building. Meanwhile, Governor Nicholas appointed architect and engineer Maximilian Godefroy to undertake extensive overhauls of Capitol Square and the Capitol Building. Warrell foresaw Godefroy's work burying the museum.

Warrell wrote in the summer of 1816 that "upon repeated assurances from Mr. G that [the museum] could not be injured but might be greatly benefited consented to exchange the spot first marked." The revised location was a damp ravine in the southeast corner of the square.

Godefroy assured the artist that the displaced earth would rise only "nine inches above the curbstones." Warrell made his anxiety known to Governor James Preston in a February 25, 1817 letter. Godefroy's work continued without alteration, which first, delayed the museum's construction and second, confirmed Warrell's anxiety.

As Godefroy's work continued without alteration, Warrell's own aesthetic dream underwent many modifications. Contemporary accounts describe a two-story, unornamented, slate-roofed, ninety-one- by fifty-foot brick building with a stucco finish. This was the museum that opened on October 6, 1817.

Visitors viewed an interior unobstructed from end to end. The large, high-ceilinged central room displayed more than one hundred paintings. The sculpture gallery featured casts of Greco-Roman antiquity; however, according to historian Samuel Mordecai, because of the statues' nudity, "fastidiously modest" Richmonders wouldn't venture there for fear of being seen by others. Admission was not inconsiderable: fifty cents or half that for children and, on occasion, "people of color."

The U.S. economy crashed in 1818. Lorton and Warrell dissolved their partnership in March 1819, leaving Warrell to administer the place and somehow repay his former brother-in-law.

Warrell's often-grueling city-to-city life of the circuit performer, then artist, exposed him to some adversities. He trained as a dancer, and until 1808 ran an academy in Shockoe and painted sets for the Petersburg Thespian Society, for which his parents sometimes performed. By 1815, Warrell's wife Rebecca was gone and their son Horatio died in 1820. Warrell married Sarah Wright and in 1816 the couple became parents to son James, although at age eleven he drowned in the James River.

Warrell sought to increase museum visitation through the staging of special events illuminated at night, the original Art after Hours. These included tightrope walkers; concerts on odd instruments including the Celestina, a device that made music from spinning glasses filled with liquid touched by the player's fingers; and traveling novelty exhibitions, including Maelzel's famous and mysterious Automata, a chess-playing "machine" immortalized seven years later by Edgar Allan Poe after he deduced it was operated by a man hidden inside.

In January 1820 Warrell published that a museum relying "on the exertions of an individual alone, must sink, unless supported by the patronage of a liberal public." He encouraged hoteliers and boardinghouse keepers to inform their guests of the museum's collection of stuffed animals, including a "very large" alligator.

Before Art after Hours

Warrell petitioned the general assembly in December 1820 for assistance. Warrell's museum built on the granted ground "at an expence *[sic]* which has reduced him and his family nearly to poverty" was sustaining "immense injury" from the Capitol Square improvements.

Dirt heaped against the walls caused separation from the roof, precipitating leaks and, further, the heaping above the foundation covered "the basement story with water & this produces a humidity through the whole building." Witnesses attested to the damage and inevitable disaster. Despite a smelly and damp experience, the museum recorded 1,400 visitors in 1820, and nearly the same the year before. They could peruse among the some twenty thousand objects. The museum needed a certain novelty to survive, but in a limited market of about 13,000 people, frequent repeat visitation wasn't.

In January 1822 Warrell, with permission, installed logs to divert water "continually seeping from the spring in the North east part of the Capitol Square" that caused basement flooding. Warrell announced in February the establishment of a "National Gallery of Portraits" with the first being his copy of a full-length George Washington portrait. He also traveled to Jamestown to create a "picturesque theater" depicting the English landing and settlement.

Warrell needed to raise money and public awareness. From 1826 to late 1830, he traveled, making art and acquisitions in New Orleans; Natchez, Mississippi; and New York City. The museum's caretaker was a business associate, William Harris Jones. Matters didn't improve, but in early 1831, the museum was "refitted in the best possible manner" for such works as Correggio's *Jupiter and Antiope*. The Hall of Paintings was "lighted up every Tuesday, Thursday and Saturday evenings."

Visitation dwindled. Mordecai describes how a mouse that was intended as breakfast for a snake, the museum's single living exhibit, attacked the sluggish reptile and nibbled on the head until the snake died.

Then "a party of playful girls" sneaked into the sculpture gallery to put skirts, hats and jackets on the plaster statues. When rumor circulated, "a perfect rush was made to see the celestials in their new or rather old attire, appareled as mortals."

By May 1832, Warrell hadn't repaid Lorton, who sold the museum and its contents, some of which were acquired by the Valentine family and formed the early core of what evolved into the Valentine Richmond History Center collection.

Warrell continued traveling and painting. Though he was in Richmond during the 1830s and 1840s, his later whereabouts are unknown, and he died sometime prior to 1854. The museum building became the Richmond

Post Office until, around 1847, it was demolished for a city courts building. This structure burned during the April 1865 Evacuation Fire. Today's state government Washington Building is near the site.

Originally published April 2006.

Old, Old City Hall
Robert Mills's Domed Municipal Temple

The orchestral announcement of municipal splendor that is Old City Hall, built 1887–94, supplanted a block of buildings: the Greek Revival city hall of architect Robert Mills, the First Presbyterian Church and a home of Governor Edmund Randolph.

Randolph (1753–1813) served as Revolutionary War aide to George Washington, a member of the Continental Congress, governor of Virginia, the United States' first attorney general and secretary of state. In 1795, however, he was accused of sliding government secrets to the French. Despite public disgrace, he retired to a lucrative law practice that necessitated his settling in Richmond. Alongside John Wickham, he defended accused traitor Aaron Burr during his 1807 Richmond trial.

The Randolph house at 1002 Capitol Street was approximately fifty-five feet long and twenty-two feet wide, of two stories on a high full basement. Insurance documents indicate a unique octagonal shape, but photographs offer conflicting testimony. It was built of brick, although subsequent owners applied stucco and enclosed the front entry with gracious, twin-stair porches. The Reverend H.A. Tupper family, he of the Baptist Foreign Mission Board, were the Randolph house's last residents.

The first city hall was built during 1816–18 facing Broad, Capitol and Eleventh Streets. Robert Mills (1781–1855) of Charleston, South Carolina, was selected as architect. Mills designed several Richmond houses and Monumental Church. His unfussy, elegant Greek Revival style sought to set the standard for architecture in the new republic. Mills practiced as one of the nation's first native professional architects in Washington, D.C., Philadelphia and Baltimore.

He was the U.S. government's official architect from 1836 until 1851. Mills created two Washington Monuments, the one in D.C. and another in

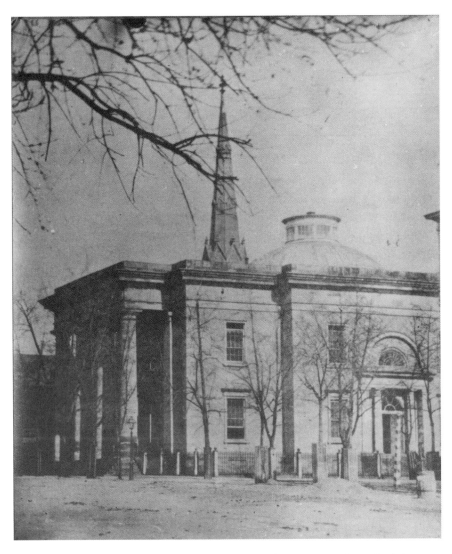

Richmond's first city hall, designed by Robert Mills during 1816–18, survived the Civil War, about which time this image was taken, but poor interior modifications, impatience and hysteria provided pretext for its 1874 demolition. First Presbyterian's 160-foot spire rises above. *Courtesy of the Cook Collection, Valentine Richmond History Center.*

Old, Old City Hall

Baltimore. He also designed the Treasury Building (1836) and the Patent Office Building (1836), where today are the Donald W. Reynolds Center for American Art and Portraiture and the National Portrait Gallery.

Mills's city hall, budgeted for $50,000 in June 1814, gave a respectable presence to the city's center. The identical and imposing north and south façades presented distinguished columned porticos.

The Eleventh Street entrance led to a pair of curving stairs (resembling Monumental Church's design). City business and court proceedings were conducted in a large circular courtroom with a low dais for city officials and judges.

Ill-considered 1850s modifications to the drum of the rotunda weakened the building. It was nonetheless the scene for Richmond's official surrender at the Civil War's end. After the horrific 1870 collapse of the overcrowded courtroom in the capitol, all older buildings were suspect. In 1874 the *Richmond Dispatch* declared, "The testimony is all against [City Hall] and is damning…and down the old building must come."

After the structure was ripped to pieces, its walls were found to be rock solid. The site remained vacant until the Victorian Gothic city hall construction began in 1887.

First Presbyterian Church proved more resilient. It was built just west of the Randolph house, overlooking Capitol Square, during 1852–53. The later architect of Philadelphia's City Hall, John McArthur Jr., designed the church in "Byzantine style." Contractors John and George Gibson built First Presbyterian with its 160-foot-high spire in seventeen months. Stucco with the appearance of stone and decorative embellishments lent the church a stronger appearance than the construction time indicated.

The base of its tower formed a vestibule for the entrance while, inside, galleries were supported by "octagonal iron shafts…surmounted by rich Byzantine capitals, from which [sprang] cusped spandrels or archivolts," giving the effect of vaulted ceilings.

The city began planning for its new offices in 1884. First Presbyterian's congregation chose to dismantle the church and move it to Madison and West Grace Streets. John Gibson again oversaw the task with the aid of the city. The landmark spire was removed in 1911 after nervous city engineers judged many of the city's steeples as hazardous. The congregation moved in 1940, following great debate, to 4602 West Cary Street. The old church was sold to the Acca Temple, and then razed in 1955 for a parking lot.

Originally published October 2001.

Queen Molly
She Would Have a Food Network Show Today

Mid-nineteenth-century Richmond historian Samuel Mordecai credits Mary Randolph (1762–1828) with giving Cary Street its name and inventing the first practical "refrigerator," an icebox that was later patented by a Yankee who stayed at her boardinghouse.

Mordecai describes Randolph as "one of the remarkable and distinguished persons of her day." Her *Virginia Housewife* guide to the culinary arts, published in 1824, is still in print and provides an invaluable perspective on Virginia domestic culture of the early 1800s.

Mary—or "Molly"—was born at her grandfather's Chesterfield County plantation, Ampthill, now the site of the Dupont plant (in 1929 the house was moved to the end of Ampthill Road off West Cary Street Road). Mary was the eldest child of Thomas Mann and Ann Cary Randolph of Tuckahoe Plantation in Goochland County. Peter Jefferson, Thomas Jefferson's father, tutored Mary and her siblings.

Around 1782, Mary wed first cousin David Meade Randolph (1760–1830). This was family tradition; one historian describes the sprawling Randolph genealogy as "a tangle of fishhooks." David served in the Revolutionary War, and cousin Thomas Jefferson urged President George Washington to appoint him U.S. marshal of Virginia. John Adams kept him on.

Mary and David parented eight children, four of whom reached adulthood: Richard, William Beverly, David Meade and Burwell Starke. During their marriage's early years, the couple lived on their estate in Chesterfield County, called Presquile—"pesqu'ile" means "peninsula" in French, and the lands sat on a remote thumb-shaped jut into the James River that is also called Turkey Island. The 750-acre plantation was nonetheless sited on swampy, unhealthy ground that caused David Randolph's "young and amiable wife" to fall into persistent illnesses.

Queen Molly

The much-altered house, dated in error to the late nineteenth century by the National Park Service, was demolished in 1964, leaving two colonial mansions standing in Chesterfield. The Randolph acreages are now the Presquile National Wildlife Refuge.

By 1798, Molly and David were sick of the Chesterfield swamps and built a large house with extensive grounds bounded by Fifth, Main, Sixth and Cary Streets. Their waggish gentleman acquaintance, Edmund Wilson Rootes, dubbed the urban estate "Moldavia." Rootes thus punned on the Randolphs' first names, joked about the size of the estate by comparing it to the same-named Romanian principality and further tweaked David for his political patronage employment and wealth by referring to him as "the elector of Moldavia." Electors of the Holy Roman Empire were royalty who elected the king or emperor.

The Randolphs entertained often and in a lavish manner. At the center of it all was Mary, who possessed a genius for hostessing. In 1800, when slave Gabriel Prosser sought to ignite an insurrection, Prosser stated he would spare Mary Randolph's life and make her his queen because of her reputation as a fine cook.

The parties at Moldavia came to an abrupt end when political opposite President Thomas Jefferson tossed his cousin from office and into the tobacco-fueled recession of 1800–02. The Randolphs were forced to sell Moldavia and other properties, and they moved to Shockoe tenements in 1300 East Cary, the approximate site of the Columbian Block. There, in March 1808, the unsinkable Molly Randolph did something few upper-class Virginia women would have thought to do: she opened a boardinghouse. She may in part have chosen to do so because, due to a prior mortgage, she retained her servants.

Martha Jefferson Randolph, Mary's sister-in-law, could spare no optimism for the enterprise. Martha wrote her father that "Sister Randolph" had "opened a boarding house in Richmond, but…has not a single boarder yet." Martha believed that "the ruin of the family is still extending itself daily."

Mordecai said in his delightful, chatty way,

> *Mrs. R, who lacked neither energy or industry, determined to open a boarding-house, feeling assured that those who had, in her prosperity, partaken of her hospitality, would second her exertions when in adversity. The friend who had named Moldavia, now conferred on her the title of Queen, and aided in enlisting subjects for her new realm.*
>
> *This was on Cary street (a name which she conferred), in a house which now constitutes a small portion of the Columbian Hotel. It was then a*

quiet spot, with very few houses in its immediate vicinity. The Queen soon attracted as many subjects as her dominions could accommodate, and a loyal set they generally were. There were few more festive boards than the Queen's. Wit, humor and good-fellowship prevailed, but excess rarely. Social evenings were also enjoyed, and discord never intruded.

Queen Molly perfected her kitchen science, receiving assistance from her subjects, the servants, as Karen Hess notes in her commentary on a 1984 reprint of *The Virginia Housewife.*

They stood in front of a large main fireplace, swinging cranes and using devices to control cooking temperatures. Molly kept kitchen operations smooth. She'd admonish, "Let everything be done at the proper time, keep everything in its proper place and put everything to its proper use."

David, meanwhile, was not brooding his fate in the darkness of a shut-up room. He became an agent for the Henry Heth (pronounced like *teeth*) Black Heth Coal Mines near Midlothian in central Chesterfield County. David traveled to England and Wales to study mining operations to better serve Black Heth. Proving himself no dolt, he received patents in 1815 for improvements in shipbuilding and candle making and in 1821 for advancements in drawing liquor.

Mordecai recalled the concluding days of the queen's establishment: "In the course of a few years, noise and dust interfered with the royal comfort, and the throne and its supporters were transferred to a mere pleasant palace, where they remained until the abdication of the sovereign."

In 1819, the Randolphs, aged in their sixties, moved to Washington, D.C., to live with their son, William Beverly Randolph. Mary compiled her advice and recipes for *The Virginia Housewife,* writing in her preface, "The difficulties I encountered when I first entered on the duties of a house-keeping life, from the want of books sufficiently clear and concise to impart knowledge to a Tyro, compelled me to study the subject, and by actual experiment to reduce everything in the culinary line, to proper weights and measures."

She derived from life experience this timeless advice:

The government of a family bears a Lilliputian resemblance to the government of a nation. The contents of the Treasury must be known, and great care taken to keep the expenditures from being equal to the receipts…The prosperity and happiness of a family depend greatly on the order and the regularity established in it. Management is an art that may be acquired by every woman of good sense and tolerable memory.

Her clear recipes include those for "toasting ham," baking, roasting or broiling shad, sweet potato pudding, cornmeal bread and battercakes. She combined her knowledge of English cooking with Native American influences and introduced African ingredients learned from her servants. She also promoted the use of garden-fresh vegetables, making her almost contemporary. She urged cooking vegetables to tenderness and in her dishes used herbs, spices and wines. Mary's apple fritters use slices of apple marinated in a mixture of brandy, white wine, sugar, cinnamon and lemon rind. She included instructions for making ice cream.

The recipes aren't fussy or elaborate and may reflect Mordecai's description of her board's infrequent excess. "Profusion is not elegance," she stated, and one feels it was a philosophy she carried beyond the kitchen. Further demonstrating her domestic goddess nature, Mary explained how to make starch, soap and blacking. She gave instructions for the cleaning of knives, forks and silver utensils. There's even a rudimentary deodorizer bearing the poetic designation of "Vinegar of the Four Thieves."

"This vinegar is very refreshing in crowded rooms," she explained, "in the apartments of the sick; and is peculiarly grateful, when sprinkled about the house in damp weather."

Mary spent her remaining years caring for her crippled youngest son, Burwell Starke Randolph, who while as a midshipman plummeted from a mast. The Randolphs moved into the residence of George Washington Parke Custis and Mary Ann Randolph Fitzhugh—known today as Arlington House. Not far from the mansion, Queen Molly chose her gravesite. She died in 1829, and David the next year. Mary Randolph's was the first burial in what became Arlington National Cemetery.

Burwell composed his mother's epitaph: "Her intrinsic worth needs no eulogium. The deceased was a victim to maternal love and duty. As a tribute of filial gratitude this monument is dedicated to her exhaulted [*sic*] virtue by her youngest son."

Queen Molly's guide, recognized as the first regional cookbook written in the United States, was published in six editions during the three decades following her death and remains in print and on the Internet.

Originally published in November 2004.

The Gangs of Richmond
Hooligans and Mischief Making

In the 1800s, Richmond was cool for cats—cats in gangs, that is. During the decades prior to and following the Civil War, young Richmond boys defended their neighborhood streets with rocks, bricks, slingshots and sometimes shotguns and small-caliber pistols.

One veteran street warrior described the most contemptuous expression a boy could hurl at another as "cat." Through use, it may have come to mean "boys." They were called the Butchertown Cats, the Oregon Hill Cats, the Gully Nation Cats, the Fourth Street Horribles, the Clyde Row Gang, the Hobo Gang, the Lulu Gang, the Bumtowners and the Sparrows of Monroe Park.

According to various accounts, about four large and thirty-three splinter gangs—"some of them downright tough"—flourished in Richmond during the mid- to late nineteenth and early twentieth centuries. These were bare-fisted, prank-pulling, fruit stand-stealing, brick-throwing hooligans.

Martin Scorsese's 2002 film *The Gangs of New York* depicts anarchic bands of cruel and ruthless criminals. It was inspired by journalist and author Herbert Asbury's 1920s–30s series of quasi-histories about the criminal underworlds of the nation's major cities. Richmond's young ruffians were more playmates than felons, but they got chronicled, too.

A short memoir published in 1938 by Charles M. Wallace—*The Boy Gangs of Richmond in the Dear Old Days: A Page of the City's Lesser History*—recalls with fond vividness the pitched rock battles and the welts, bruises and bloody noses. But Wallace also recounts impromptu circuses and parades organized to please girls.

Then there was such mischief as shoving pebbles on the tin roofs of trains passing through the Gambles Hill tunnel, causing "a terrible sound" that would make passengers fear the tunnel was collapsing. Wallace describes,

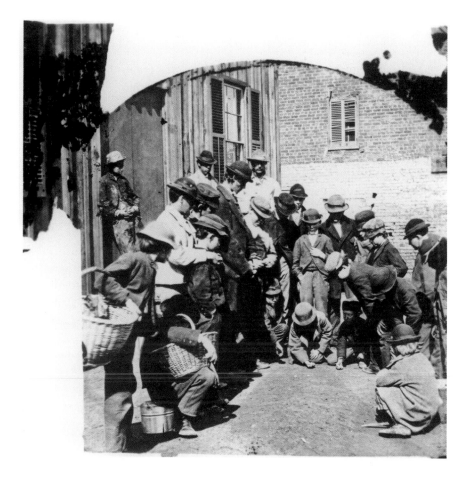

This group of boys, shown here in a Richmond alleyway around 1880, was cool for cats. *Courtesy of the Cook Collection, Valentine Richmond History Center.*

"Ladies would faint—ladies actually fainted in those days—gentlemen would feel the cold sweat oozing from their scalps and complaints would be filed with the railroad."

The formation of these gangs grew out of Richmond's physical and economic geography, of roads that didn't bridge the deep ravines separating various communities. Fairly prosperous Richmonders resided on the city's vaunted hills, while the workers and laborers tended to live in the valleys and along the river, the canal and near the Rocketts docks.

Artist and historian Edward V. Valentine, who seems to have allied himself with the Butcher Cats, recollected that Richmond's rises and valleys suggested heroic military operations. "Battles were lost and won on the picturesque slopes of the adjoining hills. For generations, it can almost

be said, warfare had been the favorite pastime with Richmond's youthful Highlanders and Lowlanders."

The Butchertown Cats and Shockoe Hill Cats, for example, fought for the flats between them. These Butchertown boys seem to have come from both Butchertown (also known as Shedtown, where tradespeople lived) and Union Hill, smaller neighborhoods north and east of Church Hill, beginning at about North Seventeenth and Venable Streets.

Wallace wryly notes, "The Butchertown boys said [the flats] was theirs because the territory was not on the hill; while the Shockoe Hill boys contended that it was theirs because it was on their side of the [Shockoe] creek; which are arguments as sound as those that are used by the most powerful nations of Europe."

Charles Wallace belonged to the Clyde Row gang, named for a group of houses along 101–131 West Cary Street between Adams and Jefferson Streets. The neighborhood kids played in the empty lot behind the row and styled themselves as a gang. One of their friends was an African American man named Charles Robinson, who frequently passed by the field carrying odd items: a new tin pan, a bass viol "as tall as himself" or a "brass-mounted, flintlock horse pistol, to fire blank charges, as his contribution to the general din."

Some of these scamps grew to be community pillars, among them a district attorney, a company treasurer, insurance agents, the police chief of Manchester, the chief of the Richmond fire department and a *Times-Dispatch* editor. Valentine thought that even Edgar Allan Poe might have participated in a tussle or two.

During the 1930s a newspaper writer lamented how in his day "a youth from the West End may go on an errand to North Seventeenth street and return without so much as being called a 'sissy.'"

Originally published March 2003.

The Manchester Diamond
Ben Moore's Big Find

Benjamin Moore, a working man with a wife and six kids and rent to pay, found what everybody dreams of, and then lost it.

In May 1854, the *Dispatch* described Moore as "a worthy, industrious, hard-working resident of Manchester." He was in his mid-fifties and married to Martha, the mother of their five sons and one daughter. Moore worked for contractor James Fisher Jr. By shovelful and cartload during early April, they were leveling a hill at Ninth and Perry Streets near the stable of the mansion of the late Judge Samuel Taylor.

On the job, Moore found a large, gleaming stone about two feet down within the thick, cool, red-brown earth. He removed the object from a cluster of water-worn rocks of sandstone. The thing resembled two four-sided pyramids joined at their bases, divided into triangles, giving it some forty-three faces. Colors played across the flat sides when held to the light. Moore believed he'd found a strange hunk of glass. He presented his find to the children, who made it part of their game of jacks.

Fisher, the boss, came by one day after work. The two men sat watching the children play until Fisher reached down and brought up the shiny, clear rock. The children stopped their romping for fear that their winking plaything had gotten them into some kind of trouble.

Fisher said, "Moore, you ought to get this thing examined. It might be a diamond."

Moore visited the watch and jewelry shop of Tyler & Mitchell at 108 Main Street, near Shockoe. John H. Tyler concluded that this wasn't just a diamond, but one of 28.75 carats. The stone conducted electricity after rubbing on cloth or dry leather and, when jerked from the sun's rays into the dark, it sent forth sparks of light "resembling fairy-like blazing stars." Its form and details demonstrated "exertions of a power divine."

Then Captain Samuel W. Dewey of Philadelphia arrived in town. His appearance may have been hastened by newspaper accounts of the find. The *Dispatch* reported that Dewey was "a private gentleman, whose enthusiasm in the cause of science has led him to devote the last five years, at his own expense, to mineral explorations in Virginia."

Dewey spent those years in the Danville region, digging and perhaps prospecting. The *Richmond Enquirer* in March 1854 referred to him as a "noble old tar" when quoting other sources in Pittsylvania County. This may refer to an actual or implied past career as a sailor, or "tar." The *Enquirer* suggested that his collection of mineralogical curiosities should be installed at the University of Virginia.

Dewey showed up in Richmond flaunting his cabinet of rock oddities, such as "elastic sandstone"—porphyratin, marble, gold, iron and coal. He subjected Moore's stone to tests, dragging it across glass and agate, leaving a mark but not giving the stone a scratch. He baked it in a furnace for two hours to see if extreme heat would cause damage. The stone wasn't harmed, and Dewey proclaimed it genuine. He speculated that an ancient flood had carried the diamond from the mountains.

Moore's rock, one of the biggest diamonds ever discovered in the United States, received a valuation of $4,000. This could have kept the Manchester laborer and his family in a higher rent bracket for quite some time, but Benjamin Moore never saw a dime. Or maybe a few dimes trickled down to him, since the diamond went on an educational display for 12 cents a person, thanks to Captain Dewey.

Following the true form of American hucksterism, Dewey christened the stone as the exotic "Om-i-Noor," which he claimed meant "Son of Light." The name, the papers explained, was given to "distinguish it from [the] celebrated Koh-i-Noor, or Mountain of Light diamond, presented by the East India Company to Queen Victoria."

Dewey told Moore he'd take the stone to New York City, try to sell it and share the proceeds with him. Moore agreed. And that was the last he ever saw of Captain Dewey.

Before long, Moore knew he'd been rooked and tried suing Dewey in the Sixth Circuit Court of Judge John B. Clopton.

Meanwhile, the "Om-i-Noor" was exhibited at the Ball, Black & Co. jewel shop in New York. The diamond was afterward cut, due to a slight imperfection, reducing its size to almost twelve carats. Then Dewey made the diamond his collateral against a loan from one J. Anglist, but he couldn't redeem it. Anglist used the diamond as collateral in a transaction with John "Old Smoke" Morrissey.

The Manchester Diamond

Morrissey, a bare-fist boxer, in 1858 won the title of heavyweight champion of the world when he defeated John C. Heenan after eleven rounds. The flamboyant Morrissey co-founded in 1863 the Saratoga Springs racetrack in upstate New York, with the help of Commodore Cornelius Vanderbilt, railroad baron Jay Gould and Winston Churchill's grandfather, Leonard W. Jerome. Morrissey developed the track's famous luxury gaming room and sometimes dealt faro. Morrissey served two terms in Congress and won a New York State Senate seat in 1878 but soon died. Today, the whereabouts of the diamond are unknown.

Originally published August 1998.

Update: In a strange connection, "Old Smoke" Morrissey turns out to have been a great-uncle relation of former and controversial Richmond attorney with pugilistic tendencies, Joseph D. Morrissey. When the author spoke to Morrissey in 1998, he, with a chuckle, assured me that he didn't have the diamond.

Dahlgren's Raid
Yankee Cavalry Tries to Take Richmond

New Jersey Brigadier General Hugh Judson Kilpatrick persuaded President Abraham Lincoln to end the Civil War with one bold stroke in March 1864.

Described as lantern-jawed and bush-sideburned, Kilpatrick was a combination of courageous and crazy. His sobriquet was "Kill Cavalry," either because he didn't care how many soldiers died or because his horse got shot out from under him during Gettysburg.

Kilpatrick talked to whoever would listen about a strike on Richmond to free prisoners and cause panic. He felt the city wasn't well defended. The idea reached the ears of President Lincoln, who invited the cavalryman to the White House on February 12, 1864.

Lincoln appreciated boldness, even audacity, among his generals. He knew Kilpatrick's reputation, but Lincoln also wanted an amnesty proclamation distributed in the Richmond environs, hoping to induce Confederates to surrender. The president avoided military bureaucracy by endorsing Kilpatrick's scheme himself. Lincoln sent Kilpatrick to Secretary of War Edwin M. Stanton for discussion about the raid's details. What they said isn't known.

Army of the Potomac commander General George Meade disliked Kilpatrick's methods but signed off on the plan, saying he didn't want to know any details. On record as opposing the scheme is Major General Alfred Pleasonton, head of the cavalry corps. Kilpatrick handpicked the 3,584-man force. His secondary commander was the youngest colonel in the army, the twenty-one-year-old, fair-haired Ulric Dahlgren, scarred by war and wearing a prosthetic right leg due to amputation after a Gettysburg injury.

"He appeared unannounced at Kilpatrick's headquarters one day, said he had heard there was going to be a big cavalry raid, and told the general that he wanted to be in on it," writes historian Stephen W. Sears.

Dahlgren's Raid

The raid began with a successful feint by Brigadier General George Armstrong Custer into Albemarle County from February 28 to March 1, 1864.

Kilpatrick also set out on February 28 and brushed aside forward pickets placed by Confederate Major General Wade Hampton. Kilpatrick crossed the Rapidan River while Richmond's defenders scrambled to place men and guns at the city's approaches.

Kilpatrick's plan called for his column to fall upon Richmond from the north, while Dahlgren and five hundred men crossed the James River, broke into the city through Manchester and freed the captives of Libby Prison and Belle Isle.

But Kilpatrick encountered resistance before Richmond. He re-crossed the Chickahominy River at Mechanicsville with Wade Hampton's cavalry in pursuit. Kilpatrick fled to Union lines at New Kent Courthouse by March 4.

Dahlgren knew none of this.

On March 1 he was causing mischief at three Goochland County estates, all within sight of each other—Eastwood, Dover and Sabot Hill. At Eastwood, Brigadier General Henry A. Wise, the antebellum Virginia governor who ordered the hanging of abolitionist/insurrectionist John Brown, escaped Dahlgren's attention due to a last-minute warning. Dahlgren moved on to Dover, that he in error thought was the home of Confederate Secretary of War James A. Seddon. His married daughter resided at Dover but Seddon lived at Sabot Hill. Dover's barns and stables, with the horses still in them, were torched and the cattle shot. At Sabot Hill, Seddon's wife Sallie regaled young Dahlgren with stories about dating his admiral father years before the war. While the raider listened to her story of the old days, his troops burned the house's barns. (These mansions survived Dahlgren's depredations but all burned in the twentieth century: Eastwood in 1941, the columned Greek Revival Dover in 1933 and Sabot Hill in the 1920s.)

To fulfill his plan, Dahlgren needed to get across the river. He seems to have paid a free African American guide ten dollars to find a crossing place. But high water had washed all the fords, thwarting Dahlgren's advance and drowning some of his men in the process. Dahlgren suspected treachery from the guide Martin Robinson. He used his horse reins to hang Robinson from a tree. He then proceeded into the teeth of a hard sleet storm. The detachment rejoined Mitchell at Short Pump, but the combined forces failed to enter Richmond. Confederate militia stopped the raiders near today's Country Club of Virginia, at Three Chopt and River Roads.

A portion of Dahlgren's command reached safety, but the "boy colonel" and some one hundred of his men, lost in the dark, blundered toward King

and Queen County Courthouse. On the night of March 2, they rode into an ambush. Dahlgren was shot in the head and left to die in the road.

William Littlepage, a thirteen-year-old, rifled through Dahlgren's clothes, probably looking for a watch, and found documents. They appeared to be orders written in Dahlgren's own hand stating that he and probably Mitchell were to "burn the hateful City [of Richmond]" and see "Jeff. Davis and Cabinet killed."

Littlepage passed the papers to his teacher, who, appalled, handed the papers along until they came to Jefferson Davis's desk. The documents made it into the Richmond newspapers, where Dahlgren was denounced as "Ulric the Hun." His body was publicly displayed, his artificial leg stolen and a finger cut off to get a ring. Dahlgren was buried at Richmond's Oakwood Cemetery. Spy and Church Hill resident Elizabeth Van Lew arranged to have the corpse exhumed and smuggled north.

The authenticity of the Dahlgren orders has been debated since they were found. Complete proof, one way or the other, isn't possible. U.S. Secretary of War Edwin M. Stanton collected all papers related to the Dahlgren affair, and they have not surfaced. There are surviving photographs of the documents Dahlgren carried and these appear to prove, to some students of the incident, that they are genuine.

Meade and Kilpatrick denied the accusations to the public. Meade, writing to his wife, referred to "collateral evidence" in his possession, coupled to Kilpatrick's reputation, that indicated the Dahlgren papers were real. Kilpatrick was ordered to investigate any wrongdoing, and he found none. He claimed the papers were a Rebel trick. He was transferred to the war's western theater. The Sears essay "The Dahlgren Papers Revisited" makes the strong case that Kilpatrick devised the secret orders. Dahlgren, an inexperienced and foolhardy commander, transcribed Kilpatrick's instructions with the intention of using them in an address to his troopers.

In response to the raid, Confederates hatched plans to kidnap Lincoln and blow up the White House. The Confederate intrigue came to nothing, but one sympathizer involved in the abduction plot got his moment. His name was John Wilkes Booth.

Originally published March 2006.

The Horse Thief on the Pyramid
Capping Hollywood's Monument

On November 8, 1869, a dark-haired, hazel-eyed, tattooed horse thief from Lynchburg provided the solution and muscle for dropping the capstone onto the top of the pyramid in Hollywood Cemetery.

Hollywood, now one of the city's most revered historic sites and a prime tourist destination, was conceived amid controversy and political infighting. Nearby landowners concerned about their property values almost prevented the cemetery's establishment. The reinterment of James Monroe quelled controversy in July 1858. The burial of eighteen thousand soldiers killed in the cataclysm of the Civil War further sanctified the park-like grounds. The dead were brought from close and distant battlefields, including Gettysburg. Hollywood became, as its directors stated in 1858, "the Pantheon of Departed Worth—the future Mekha of the Old Dominion."

The women of the Hollywood Memorial Association sought to raise money to erect a chapel or monument to Hollywood's Southern war dead. In the spring of 1867, a tremendous and successful two-week bazaar held on three floors of a warehouse at Main and Fifteenth Streets raised money for the undertaking. The eventual $18,000 in contributions came from across the country, England and France.

The chosen monument design originated from engineer Charles Henry Dimmock, whose submission was a ninety-foot pyramid made of large blocks of James River granite. These blocks were stacked without any bonding. The cornerstone was laid on December 3, 1868, bearing the inscription: "Erected by the Hollywood Memorial Association, A.D. 1869 To the Confederate Dead Memoria in Aeterna Numini et Patriae Asto." ("In eternal memory of those who stood for God and Country.") Dimmock, a civil engineer, during the war supervised the completion of Petersburg's defenses and provided early impetus for Richmond city parks. (His brother,

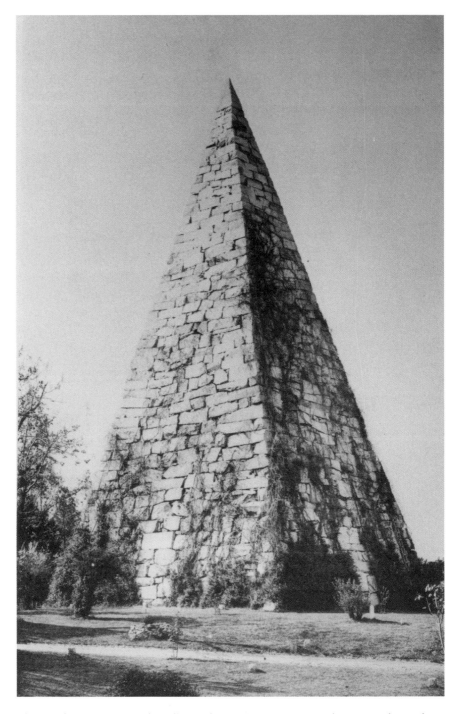

The Confederate Memorial, Hollywood Cemetery, circa 1897. Thomas Stanley, perhaps using a sailor's knowledge of ropes and knots, topped this off. *Courtesy of the Valentine Richmond History Center.*

The Horse Thief on the Pyramid

Marion Johnson Dimmock, 1824–1908, also a Civil War veteran, became one of Richmond's most prolific architects.)

Charles Dimmock died in March 1873 and is buried in Hollywood. But no plaque honored him or his pyramid until relatives placed one at its base on April 20, 1991.

The memorial took a year to construct. If you have ever played a game of trying to stack blocks without toppling them, this closely resembles the engineering exercise that was the Hollywood pyramid. There were accidents and injuries and the stone-hauling derrick broke several times. Further problems were expected on November 8, 1869, when the moment came to place the capstone. This required someone to clamber to the top of the pyramid and guide the stone into position as the derrick lowered it.

Part of the construction crew included prisoners from the nearby state penitentiary, located on Spring Street across Belvidere Street, where Ethyl's complex now sits. Thomas Stanley from Lynchburg volunteered. He had been taken into the state pen as prisoner #3362 on July 3, 1866. Lynchburg's circuit court sent him there for five years on the charge that on May 5, 1866, he stole two horses worth $200 each from Cain Calmon. Stanley was twenty-two years old in 1866, five foot ten with tattooed arms. On the inside of his right arm, in India ink, was a woman with the American coat of arms above her head, and on the other side there was a female holding a waving U.S. flag. "Other figures in India ink on the left arm," the dutiful prison record book notes.

In early 1868, Stanley submitted, in handsome handwriting, a plea for a pardon to Virginia Governor H.H. Wells. Stanley apologized that he'd been ignorant of the law prior to his conviction, but insisted that he had taken the time to educate himself.

Wells reviewed the petition and commented that Stanley's arguments had "no evidence of genuineness nor anything to indicate meritoriousness." Stanley claimed he'd been tried twice for an offense he didn't commit, that he'd been drunk and, furthermore, hired by Calmon to do some hauling for him. Calmon's version was that a black driver left his house in the morning but returned around 1:00 p.m. that May afternoon, upset and without horses or wagon. Witnesses had seen Stanley board the wagon, struggle with the servant and throw him off. The prisoner claimed the servant was also drunk and fell.

"I would not have kept (the horses) all day in Lynchburg on the public streets in company with the colored driver…if I had intended to steal them," Stanley wrote. Daniel Calmon, Cain's brother, organized a posse and headed Stanley off at the pass.

And thus it was that a horse thief came to be on the work gang for Dimmock's pyramid. The knots in the hoisting ropes were tied too close to the top and the stone wouldn't go past them. Stanley poured water on the ropes, causing them to shrink the needed inches. Then, as a breathless crowd watched, the prisoner put himself between the mass of hanging rock and the pyramid and righted the stone to its seat. The Richmond *Whig & Advertiser* remarked that the onlookers "lustily cheered him for his fearless and heroic conduct."

For years the story was repeated that Stanley was soon granted a pardon for his effort, but the record doesn't support the legend. Or does it? In the release box of his prison schedule, the simple penciled notation reads "transferred." There is no mention of when or where. A romantic notion suggests itself: the warden opened a gate and told Stanley to go and never come back, although this scenario contradicts the non-ACLU penal philosophy of the mid-nineteenth century. While Thomas Stanleys appear in the 1870 and 1880 Virginia census, their ages are too varied to be the man who was at Hollywood on that November day. If his pro-Union tattoos are any clues, so close to the end of the Civil War, perhaps this Stanley wasn't a Virginian.

Stanley's story may have earned him a few drinks at some bars. So if you think of Thomas Stanley at the appropriate time, hoist one in his memory.

Mary H. Mitchell's *Hollywood Cemetery: The History of a Southern Shrine* provided background information for this article.

Originally published October 1996.

The Municipal War of 1870
Richmond Had Two Mayors

Richmonders went to the polls in November 2004 and for the first time in more than a half century elected a mayor for themselves, rather than city council appointing one for them. Somehow, not a shot was fired. March 1870, however, was quite different. Five years after the Civil War, Richmond's acrimonious Reconstruction-era government kept fighting. The antagonists consisted of cantankerous ex-Confederates and victorious zealots—and some outright opportunists. In January 1870, Virginia was allowed to rejoin the Union. Military occupation ended.

On March 16, 1870, Richmond Conservatives tried to oust the Reconstruction Republicans. Virginia's governor in 1870 was New Yorker Gilbert Walker, a conservative Republican acceptable to Virginia Democrats. He'd been enabled by the legislature to remove city appointees, even incumbents, until formal elections on June 1. The mayor was twenty-nine-year-old George Chahoon, a radical Republican from upstate New York.

A new council met and elected as mayor Henry K. Ellyson, publisher of the Richmond *Dispatch*, a former city sheriff and a Conservative party founder.

Chahoon refused to step down, citing as his reason the fact that Ellyson had reinstated Chief of Police John Poe Jr., whom Chahoon had suspended after a drunken Poe assaulted a Republican politician. Poe's treatment of black citizens wasn't much better.

For several weeks, Richmond had two courts, police forces and city officials loyal to one side or the other. Chahoon loyalists seized the First Market House at Seventeenth and Main Streets. He deputized African Americans into a special militia commanded by "Colonel" Ben Scott, who had trained black Confederates. The Conservatives occupied the domed city hall after shooting live rounds at a nervous group of majority African American defenders.

There was much excited running about, proclaiming this or the other side legitimate. Governor Walker refused to assist Chahoon. Then, into the drama entered a living artifact, former Virginia Governor and Confederate General Henry A. Wise. His almost final act as governor in 1859 sent to the gallows abolitionist and revolutionist John Brown. Here, Wise himself emerged, as if from a crypt, to broker a truce. He failed.

On Friday, March 18, 1870, Ellyson partisans cut off the Chahoon Republicans' food, water and gaslights, and then cordoned off the building from visitors. The Chahoonists realized they had barricaded themselves on the upper level of the Market House, used as a police station and meeting hall, without any food. Despite the inconvenience, market business continued.

Brevet Major General Edward Richard Sprigg Canby, who had no authority in Richmond, responded to Chahoon's request for assistance. He sent a few mounted horsemen to get Poe's police away from the Market House. Ellyson dispatched a protest to the governor.

It had the makings of a Southern-style Gilbert and Sullivan comic opera until the first man died. Daniel Moore, a black spectator, was fatally wounded during a melee between Poe's cops and annoyed congregants. No one was charged in his death.

The arrival of blue-coated troops and the withdrawal of Poe's men toward their temporary headquarters at 1441 East Main Street gave an apparent impression of Chahoon victory. The crowds pursued the police, heckled and threw bricks. The police shot back. Bullets cut skin and where they caused no mortal wounds the gunfire broke up the crowd, which dispersed into the side streets. The police went direct to quarters. Chahoon was in fine glee and thought he'd won the day, having gotten the police force withdrawn by which he'd been besieged for thirty-six hours.

While the Municipal War's battles occurred on Main Street, the rest of Richmond proceeded almost as usual. Many of its citizens were accustomed to gunfire, as they'd lived through four years inside an enforced military district and under constant threat of attack.

George H. Clarke, a Richmond College student clerking in his family's Main Street store, noted in his diary, "Today we had a fight in front of the store. About a hundred shots were fired and the Negroes ran. Quite an exciting time."

Music hall comedians sang a bit of doggerel verse that evening: "Up in a balloon, boys, up in a balloon/All around the station house a-peeping at Chahoon."

An advertisement in the Saturday paper asked, "Who is Mayor? seems to be a mooted question with some, but we can inform all persons in want of clothing and furnishing goods that E.B. Spence & Son, Merchant Tailors, 1300

Main street, have a large stock of cloths, cashmeres, vestings and gentlemen's furnishing goods on hand, and are selling them very low for cash."

At the Grace Street Baptist Church, James P. Cowardin presented as a benefit for the Missionary and Library Association his "humorous representations based chiefly upon scenes in the Mayor's Court of Richmond."

If George Chahoon, given his exigent predicament, could have appreciated a sense of poetic irony, he might have tried to attend the Richmond Theatre's current play. Actor Neil Warner portrayed the title role in Shakespeare's *The Life and Death of Richard III terminating with the Battle of Bosworth Field.*

Chahoon's own drama, however, was entering its second, violent act.

Ellyson held a court in city hall, expelling and preferring charges against all Chahoon-appointed city officials. Chahoon also held a court. He made civic appointments and considered himself in command. Captain Taylor and his men captured the Second Station, but Chahoon held the Third, and he placed Ben Scott's detachment on guard in the fire department, which today houses Gallery5 in Jackson Ward.

When some of Poe's men went on the night of March 20 to arrest Ben Scott, Policeman Richard O. Busch was shot and killed. His funeral received an escort of 250 officers and the entire city council. No arrest was ever made in the case.

The whole mess went to court, and that yielded true tragedy. At the Virginia Capitol Building on judgment day, April 17, 1870, the overcrowded Court of Appeals balcony collapsed and crashed into the House of Delegates. More than sixty people died, and hundreds were injured. Funerals went on for three days.

On May 29, the Court of Appeals found for Ellyson and Poe. In the formal elections, both Ellyson and Chahoon ran. Chahoon won. But pro-Ellyson forces stole a crucial Jackson Ward ballot box. Ellyson declined to serve if associated with scandal. A second election, amid charges of widespread fraud, installed Anthony M. Keily, a Roman Catholic native of New Jersey, an editor and a Confederate veteran. Thus ended Republican rule in Richmond.

Henry Ellyson remained in Richmond, a revered and productive citizen.

George Chahoon was later arrested for forgery, tried and convicted, receiving four years in the penitentiary. A new trial still found him guilty, but gave him two years. Governor Walker pardoned Chahoon on the condition that he leave the state—which he did.

Originally published January 2004.

The Readjuster Party
Mahone's Effort to Integrate Politics

"I have thought it wise to live for the future and not the dead past," former Confederate General William Mahone wrote an old comrade in 1882. "While cherishing honorable memory of its glories, I have thought that we should look to the future for life, power and prosperity."

The ornery one-hundred-pound, five-foot-one-ish Mahone (1826–1895) was the poker-playing, tobacco-chewing, slave-owning son of a Southampton County tavern keeper. After civil engineer training at Virginia Military Institute, he ran railroads and commanded troops in battle. General Robert E. Lee promoted Mahone to major general on the field at Petersburg because of his counterattack following the disastrous mine explosion. This earned him the sobriquet "Hero of the Crater."

Mahone and his considerable family settled in Petersburg. There, in the late 1870s at the 425 Cockade Alley offices of the still-standing Southside Railroad Depot, he shook Virginia politics to its foundation as the co-founder of the Readjuster Party. He established alliances (though fractious) with like-minded mavericks, and acknowledged and exploited African Americans' new political power. By taking his cause to public meetings throughout the state, Mahone and his misfits ignited Virginia's political discourse.

Historian Jane Dailey, in *Before Jim Crow: The Politics of Race in Postemancipation Virginia*, states, "The Readjusters governed Virginia from 1879 to 1883. During this period a Readjuster governor occupied the statehouse, two Readjusters represented the Old Dominion in the U.S. Senate, and Readjusters served six of Virginia's 10 congressional districts."

The coalition of black and white Republicans and white Democrats controlled the state legislature and the courts. They held and distributed the state's many coveted federal patronage positions. The Readjusters

legitimized and promoted African American citizenship and political power by advocating the right of blacks to vote, hold office and serve on juries.

The majority of Republicans and Democrats in nineteenth-century Virginia wanted blacks out of the political process—and the fewer people voting, the better.

The Readjusters were borne of a financial dispute. By 1870, Virginia's state debt totaled $45 million. Most of it was incurred when Virginia also included West Virginia. "Funders" felt Virginia was honor-bound to pay it. Others wanted to "readjust" the debt down. The Readjusters, explains Duke University political scientist Renan Levine, "capitalized on dissatisfaction engendered by the ruling Conservatives' decision to honor their pre-war and post-war debt at the expense of public services like the fledgling public schools."

The Readjusters didn't come into full power until 1882, when the life of the Readjuster-controlled Virginia General Assembly was half over. At the time, three state senators and eleven delegates were black.

William E. Cameron (1842–1927), a Petersburg editor and three-time mayor in a majority black city, became the Readjuster governor in 1881. Cameron's administration passed unprecedented forward-thinking policies, including the abolition of anti-black voting regulations, establishing Virginia State University, increasing financial support to public schools and chartering labor unions.

By the 1883 election for seats in the state legislature, "the Readjuster party had largely fulfilled its promise and destiny," writes historian Charles E. Wynes in *Race Relations in Virginia 1870–1902*. "Lacking a continued, liberal program, it fell apart from within while wrangling over the division of spoils and future leadership."

Three days prior to voting in 1883, a race riot erupted in Danville, leaving one white and four black men dead. Democrats—who seemed to have fomented the violence—blamed Readjuster policies. The party was routed from office.

The Readjusters demonstrate that Jim Crow needn't have been inevitable, and if not preventable, at least mitigated. One tragic aspect of the Readjusters' demise was that the opportunity in 1888 to rewrite the Virginia Constitution passed by with little notice. The 1902 revision eliminated the black vote and a third of the white franchise.

Mahone's hyper-controlling leadership caused party defections, and the Readjuster coalition crumbled. He earned the ire of his own party—and the anger of Virginians—by voting with Republicans in Congress. Virginia politics turned not progressive, but regressive and oppressive.

Mahone was buried in the family tomb of Petersburg's Blandford Cemetery. His widow, Otelia, was interred alongside him in 1911. The political controversies caused the family to identify the mausoleum with nothing more than the letter "M."

"Slight indeed so far have been the vindication and recognition of William Mahone, a man ahead of his time," writes Wynes. "His was the misfortune of being a political liberal and realist in an age of increasing conservatism which sought to escape the reality by glorifying a halcyon past and creating the Confederate Cult."

Originally published April 2007.

Shadows of the People
Photography of George and Heustis Cook

Photographer George S. Cook (1819–1902) made some of the most striking images of the American Civil War and revelatory documentation of life in Richmond at the end of the twentieth century. An orphan from Connecticut who left his grandmother's New Jersey home at age fourteen, Cook fashioned his career in New Orleans, Charleston and Richmond, creating a rich body of photography stretching from 1845 to 1902.

In 1880 George Cook wrote, "There is only one thing to be done to meet success. You must get a <u>better picture</u> than anybody else can get. It is hard work sometimes; but there is <u>beauty in every face</u> (my motto) and you must find it."

When Northern ironclads attacked Fort Sumter and other Charleston fortifications in September 1863, George Cook shot back with his camera. His images show Federal monitors hammering Sumter's battered ramparts. These futuristic warships of 1863 appear alien; indeed, they resemble grainy pictures of UFOs. The image's sense of immediacy lacks only the "CNN Live" logo. A nearby exploding shell catapulted Cook's plate holders into the rainwater cistern. Cook recorded Sumter's pulverization, and during one session a shell exploded in front of him while he was exposing his plates to light. He got the picture.

Years later, while documenting the bustling commerce of Shockoe, Cook, or one of his sons, captured an evocative scene of a lorry driver and his horses rushing toward the viewer. It's almost possible to hear the clopping of horse's hooves, wagons jangling and banging, shouts of laborers and haulers and sense the heat of the day.

Young George Cook went south, along the way marrying Elizabeth Smith Francisco. They had two children before her death, Francisca and George LaGrange. LaGrange took over his father's Charleston business when he moved to Richmond, and then came here, too, in 1892. In 1866 Cook married Elizabeth's niece, Lavinia Pratt. Their children were Lavinia

Photographer George S. Cook and his family, the picture of late nineteenth-century middle-class respectability, gathered on the porch of their Bon Air home, 1886. Note the blurred image of a servant peering around the corner of the house. *Courtesy of the Cook Collection, Valentine Richmond History Center.*

Elizabeth and Heustis Pratt.

While in New Orleans studying painting and seeking to open an international art gallery, Cook discovered the daguerreotype. He embarked on his career, as a critic wrote more than a century later, "an extraordinary combination of artist and tradesman."

The Cooks settled in Charleston. Mathew Brady picked Cook in 1851 to manage his studio while Brady went abroad. Cook quickly established a gallery in New York, Chicago (1857) and Philadelphia (1858).

On April 12, 1861, Cook jotted in his Charleston business diary, "Shut up. War, war, war," noting in the margins the bombardment of Sumter. His staccato commentary noted the next day, "War. Still firing. Ships also. Fort surrendered."

Cook ran the Northern blockade for chemicals and maintained Northern and European contacts. An 1863 notice in a trade journal mentions Cook's "precarious stock of photographic materials" and notes that he was still making "shadows of the people." Elizabeth died in 1864 and a suspicious

Shadows of the People

1865 fire in Columbia, South Carolina, destroyed Cook's earliest work and documents.

At war's end, Cook photographed, in near Winslow Homer style, a solitary black man sitting amid oyster shells and rubble before Castle Pinckney. He gazes toward an archway in the massive stonework as though suddenly deposited there by history. He regards the dark passage ahead, perhaps wondering what comes next. Cook captures the bewilderment of an entire nation and people while also expressing the sadness of his own life.

Cook came to Richmond in 1880. He bought negatives and businesses of other photographers. He amassed the most complete collection of city images in one studio, but also made it near impossible to determine the provenance of many pictures.

Cook's son, Heustis (1868–1951), carried the legacy throughout Virginia by photographing physical and sociological events with exquisite voraciousness. Like Atget documenting Paris, Heustis Cook made pictures of street life and social occasions in Richmond during the first five decades of the twentieth century.

Heustis Cook's archive, discovered by scholars in the early 1950s, assured the family's place in U.S. photographic history. His widow, Mary Latimer Cook, sold the entire family collection to the Valentine Museum. The trove contains at least ten thousand images.

Books about the Cooks are available, but rare. Local libraries keep them as reference for fear the photos will be cut out. Kocher and Dearstyne's 1954 *Shadows In Silver* is the first compilation. Jack Ramsay's *Photographer Under Fire* of 1994 offers Cook images and an accounting of the family's history.

A 1954 exhibition of George Cook's pictures, titled "Southern Exposures," moved a *New York Times* writer to say that Cook's "vitality, inventiveness, imagination, ingenuity, curiosity and mastery of the photographic medium as art and craft put him easily at the top of his profession."

Originally published June 1999.

Richmond's Moving First
The Electric Trolley

The magnitude and intensity of the revolution that began in Richmond is almost without parallel in the history of technological change," declares the present-day website for the International Institute of Electrical and Electronics Engineers, speaking about Richmond's electric streetcar system, inaugurated in May 1888 by engineer Frank Julian Sprague (1857–1934).

Sprague, a Connecticut Yankee, graduate of the U.S. Naval Academy at Annapolis and colleague of Thomas Edison, overcame typhoid fever, outright hostile competitors and incompetent or uncomprehending contractors. Richmond business leaders, hearing about Sprague's experiments in transit in New York City, invited him here.

The opening suited Sprague, who sought a technological equivalent of an out-of-town tryout for a Broadway-bound play. Richmond was close enough to New York by rail to bring potential investors down to see Sprague's handiwork, and Richmond, divided by ravines, bad roads and bridges of dubious qualities, seemed an excellent place to conduct his streetcar experiment.

Sprague's May 1887 contract with the city gave him ninety days to create a working electric transit system for which no reliable model existed. Richmond agreed to pay $110,000 "if satisfactory," and if not, Sprague would be penalized. By the time his project was completed, he put in $75,000 of his own money to satisfy the contract's terms. Inventing the technology as they went along, Sprague's team built four-wheeled cars connected to an overhead wire called a troller, making the cars "trolleys."

Within two years of Richmond's success, 110 electric railroads worldwide were operating or under construction using Sprague's equipment. Richmond never owned the system; different lines that traced back to the original

Sex in the City, circa 1910: These young ladies represent the new urban, and urbane, female of the early twentieth century—fashionable, vital and using the high-tech electric trolley to commute to work or on a larkish afternoon jaunt. *Courtesy of the Richard L. Bland Collection.*

horse-drawn streetcar fought to control their routes. This differed from how city transit systems grew in Europe, using Sprague's invention, where municipalities owned and operated the lines.

Regular service started on May 8, 1888, with car No. 23 running along Seventeenth Street, operated by R.L. Gordon. Inaugural passenger A.J. Crew handed his nickel to conductor A.S. Tyler. The initial trolley network of May 1888 consisted of twenty-three cars running on twelve miles of track, though given time the track extended eighty-two miles, much of it running to suburbs that were a direct outgrowth of the system.

In 1890, Edison's General Electric Co. purchased and absorbed Sprague's business. Sprague then turned his attention to elevators, building 584 of them for the world's tallest buildings before selling to the Otis Elevator Co.

During the early 1900s, trolley cars were the favored mode of transportation and were used as a tool for development. Elaborate amusement centers were built by Richmond's transit firms and land sales companies at the end of highly traveled lines. Notable pleasure gardens were at Forest Hill Park and Lakeside.

Richmond's system was affected by cultural trends. A 1903 strike by motormen caused the calling out of the state militia, resulting in gunfire, rioting and two deaths. Firebrand African American *Richmond Planet* newspaper editor John Mitchell Jr. led a 1904 boycott of the cars due to racial segregation enforced by armed motormen. Weakened by the strike and unwilling to relent on its Jim Crow policy, the trolley car company went into receivership.

Richmond's streetcars became the property of New Yorker Frank Jay Gould and his cousin William Northrop, who had other transit interests here. Gould's firm improved the system but annoyed residents by ripping down trees on Chamberlayne Avenue, discontinuing lines and asking for rate increases.

Virginia Electric and Power Company came into ultimate control of Richmond's entire trolley system, although in 1944 the federal Securities and Exchange Commission divested the utility of its transit holdings. The system was sold to Chicago and Nashville interests. By then, buses and automobiles were making electric streetcars less relevant.

By 1949, more than one hundred electric transit systems were replaced with General Motors buses in forty-five cities. That April, a Chicago federal jury convicted GM of criminally conspiring to replace electric streetcars with buses. The ruling came too late for Richmond, though.

Political provincialism coupled with GM's machinations meant that Richmond's last trolley run was made by No. 408 along the Hull Street/ Highland Park line on November 25, 1949, with a moribund parade

gathering crowds. On December 15, 1949, at 9:30 a.m., No. 408 was burned, joining nearly all the others in a strange, Wagnerian pyre.

Since that inglorious demise, there have been efforts to revive Richmond's trolleys. This achievement eluded even powerful preservationist Elisabeth Scott Bocock, who held a 1960s trolley conference on a hot summer's day in her airless West Franklin Street carriage garage attended by the governor, state legislators and transportation experts. It generated conversation and little else.

Her enthusiasm lives on. The Historic Richmond Foundation commissioned a study due this summer about a "light-rail" electric circulator.

Originally published May 2004.

Update: Richmond leaders express in publc their wistful desire to inaugurate a "downtown circulator" but admit that it would, due to initial expense, begin as a modified bus. Meanwhile, throughout Virginia and the nation, municipalities are climbing aboard new electric light rail systems. Here in Richmond, where it started, light rail isn't part of political priorities that in the first decade of the 2000s are more concerned with edifice complexes than issues of relieving automotive congestion, lowering pollution, resolving parking problems and injecting both practicality and romance into the city's streets.

In a sidelight, the Depression-era federal regulation that stripped utilities from control of urban transit systems was repealed in 2006. Dominion Virginia, which owes part of its existence to the electric trolley through its VEPCO ancestor, could return to the business.

Colonel Cutshaw's Castle
The Byrd Park Pump House

On a warm summer's evening in 1918, music and laughter waft up to the open windows of the Brockenbrough mansion, behind Byrd Park. The sounds of revelry come from the Pump House. Subscription dances attract young and old alike to the upper pavilion of the Victorian Gothic building.

Very few Richmonders can recall those faraway summer nights and visits to the old Pump House, off the boulevard prior to the Boulevard ("Nickel") Bridge.

The Pump House is an imposing structure realized by Colonel Wilfred Emory Cutshaw, who was the city engineer from 1873 until his 1907 death. The High Gothic Revival Pump House, built of granite quarried from nearby, was completed in 1883. Justin Gunther, a former Historic Richmond Foundation intern who wrote the 2002 National Register of Historic Places nomination for the Pump House, noted, "The pointed arches, gables, lancet windows, and other Gothic details define the structure's style, which is refined by the quality of the craftsmanship."

Gunther describes how Cutshaw's

> *planning vision greatly shaped the city's growth. Cutshaw's municipal projects included schools, armories, parks, markets, and the construction of City Hall. Cutshaw promoted the tree lining of streets, and he established a tree nursery at the Byrd Park Reservoir to facilitate this goal. In fact, his design for the very grid of the city; the systematic plans he presented for laying of sewer, water and gas lines; and his recommendations for paving of sidewalks, gutters, and roads all contributed to a successful and comfortable Richmond.*

Colonel Cutshaw's Castle

The Byrd Park Pump House, shown here in 1897, was a melding of the utilitarian and the aesthetic and served as a centerpiece for a major Richmond green space. The building should be undergoing yet another revival. *Courtesy of the Valentine Richmond History Center.*

Cutshaw's inspiration for the building or the effect he desired is unknown. Perhaps he envisioned a medieval fortress, like the castles of feudal barons on European waterways. Or maybe he wanted to emulate a nineteenth-century European garden "folly," ornamental structures installed by landscape architects and designed to appear ancient and sometimes ruinous. Cutshaw's persuasion created the parks surrounding the Pump House and, given the historical period and Cutshaw's experience, this elaborate structure seems keeping in the character.

The Pump House's machinery brought water from the James River and Kanawha Canal through a diverted canal into an existing Byrd Park reservoir. The house was constructed in the middle of the 160-acre park, designed with a network of grass plots interlaced by paths, a waterfall and benches.

The westernmost side of the park received less formal treatment. A bridge spanned the 1820s canal, where one could still view the two "three-mile locks" (being three miles from downtown's Great Turning Basin). Another bridge continued southward over the late 1780s "lower canal" with its monumental stone arch. This was the canal's grand entrance and also served as a guard lock to protect Richmond from periodic James River

73

flooding. George Washington, who conceived of the canal, rode a bateau under the arch during a 1791 inspection tour.

Dr. George W. Bagby, writing in his 1879 *Canal Reminisces*, describes the Pump House's surroundings as the most pleasing of the canal lock stations. "It is a pretty place," he observes, "as everyone will own on seeing it. It is so clean and green, and white and thrifty-looking. To me it was simply beautiful. I wanted to live there; I ought to have lived there…What more could the soul ask?"

The Pump House's lower level contained the powerful and din-raising pumps, and the upper section featured an open-air, arched pavilion with a double floor of wood. Visitors enjoyed the views of water, parkland and historic canal remnants. An interior balcony overlooked the gigantic wheels of the pumping machinery. Cutshaw received criticism for the additional construction costs. The marriage of waterworks and entertainment venue endowed a building constructed to serve a pure mechanical function with a rich social history.

The open pavilion allowed rain to seep between the layers of flooring. By 1899, the space was enclosed by sash windows. A 1905 addition followed the earlier design.

To get to the pavilion, Richmonders could board a canal boat. One favorite was the *Rosebud*, on the Dolly Vardon Line, at Seventh and Canal Streets for a pleasant ride at five miles an hour up the canal to the Pump House. Young people organized subscription dances for the pavilion around World War I (1914–18). A series ticket cost a substantial $1.50. Chaperoned ladies and men from teens to those in their thirties attended these pleasant socials.

The dances started in early evenings, before darkness, because just one pair of incandescent fixtures illuminated the great hall. The bands played in the middle of the large floor, as there was neither a stage nor amplification.

One of the band members, who may have cut his performance teeth, so to speak, at the Pump House, was Horace Kirby Dowell, who picked up the nickname "Saxie." He played tenor saxophone with the Old Dominion Orchestra and the Bill Boyd Orchestra.

Dowell was born in Raleigh, North Carolina, although several Richmonders possess vivid recollection of him playing football for the McGuire School for Boys on Gamble's Hill. During a contest with John Marshall High School on Mayo Island, the game was halted when Dowell lost his fake front teeth. He kept the teeth on a pivot and removed them to play the sax.

While he was a member of Hal Kemp's swing band, Dowell composed the hit 1939 novelty tune "Three Little Fishies" and 1940's "Playmates."

"Fishies" was recorded both by Kemp and the better-known Kay Kyser. The affected pronunciation of "thwee wittle fithies" could be a reminder of Dowell's missing front teeth, and the Pump House itself, as in: "and they thwam and they thwam right over the dam."

Dowell conducted the aircraft carrier *Franklin*'s band as a World War II naval reservist. When the ship was within fifty miles of the Japanese mainland on March 19, 1945, *Franklin* received severe damage by air attack. Dowell's band first played, and then helped undertake the intense and heroic rescue operations. For Dowell, those wonderful Pump House dances must have seemed quite distant.

Those enjoyable evenings concluded around 1924. The building was superseded by a new plant next door and the old machinery was scrapped in 1935 and sold to the Japanese. That nation was using discarded metal to make armaments. Within a few years the Pump House was considered obsolete. For a half century, Colonel Cutshaw's riverside fortress deteriorated. The city marked the building for demolition in the 1950s and sold it to the First Presbyterian Church for one dollar.

The Pump House and its surroundings have escaped the fate of overgrown ruins today because of people like James Moore III, William Trout III, James River Parks administrator Ralph White and enthusiastic volunteers. Moore and Trout rescued the lower arch from trees and vines. During the Pump House's centennial, the canal folks brought small boats into the waterway. A demonstration like that wouldn't be possible some years later. Much of their earlier work was undone by unchecked nature and lack of public awareness.

The Virginia Canals and Navigation Society advocates the establishment of a Virginia Canal Museum to house unearthed canal artifacts and memorabilia. The Pump House, now in its third century, could feature exhibition space and a restaurant while the canals reopen for tourist vessels, linking the downtown riverfront to Byrd Park and beyond. Public support can bequeath to future generations a preserved section of an unusual aspect of the region's story.

Originally published July 2000.

Update: Volunteers of the Historic Richmond Foundation, the James River Parks System and others concerned with preserving and restoring Pump House continue to raise public awareness about the building. The building was accepted into the National Register of Historic Places in 2002. The next year, the Historic Richmond Foundation donated to the Library of Virginia Foundation, on behalf of Jim and Michele Riley, seventeen

engineering drawings that document the pumping equipment once located there. Pump House Superintendent Alex Delaney executed most of the ink-on-linen drawings dating between 1884 and 1907.

As it goes in most of these cases where the acceptance of a structure's importance is almost universal, what remains is raising money and establishing an administrative and maintenance regime that will please all involved. Perhaps a mass concert of Richmond jazz musicians, singers and dancers performing wild versions of Dowell's music could bring greater awareness and funds.

The Good Doctors
Sarah and Miles Jones

Her funeral at Second Baptist Church in early May 1905 caused such a large crowd that the numbers exceeded the capacity of the sanctuary. Hundreds stood outside; a Richmond *News Leader* reporter observed the presence of "all nationalities and conditions."

The occasion marked the passing of Dr. Sarah Garland Jones, the first African American woman licensed to practice medicine in Virginia.

Her uncertain birth year was just after the Civil War in Albemarle County, "in sight of the historic home of Thomas Jefferson," John Mitchell's Richmond *Planet* described in 1895. Her parents, George W. Garland and Ellen Boyd Garland, moved to Richmond in 1868. He was "the leading colored contractor in the city of Richmond" and built a number of public buildings, including Baker School, erected in 1873 at St. John and Baker Streets (now Gilpin Court).

Sarah graduated in 1883 from the Richmond Colored High and Normal School at Twelfth and Leigh Streets. Maggie L. Mitchell, who later achieved business and social success, also graduated in Sarah's class.

Sarah taught for five years at the Baker School, where she met Miles Berkley Jones. They married in 1888. The couple would have remained educators had not the racial issues of the day intervened. Miles lost his job after a city ordinance went into effect forbidding black men from teaching in public schools.

Miles belonged to the Grand Fountain of the United Order of True Reformers. This benevolent group had as one of its goals the establishment of a bank. He took on the position of director of finance.

Sarah chose to study medicine at Howard University. Upon her graduation in 1893, she returned to Richmond and opened the Richmond Hospital, with an initial twenty-five beds, at 406 East Baker Street. She

Above left: Miles Jones. *Courtesy of the Maggie Lena Walker Family Papers, Maggie L. Walker Historic Site.*

Above right: Sarah Jones. *Courtesy of the Maggie Lena Walker Family Papers, Maggie L. Walker Historic Site.*

became the first African American female physician to pass the Virginia Board of Medicine. She maintained a general practice and also performed surgeries.

The Richmond *Planet* profiled her with great enthusiasm as "the pioneer exponent of the principle of woman's rights." She helped Miles through Howard Medical School. He became a treatment specialist for the ears, nose and throat.

The doctors built a prosperous practice among the black and white communities. They traveled together in a surrey while visiting their patients door to door. Besides his medical responsibilities, Miles served forty years as Sunday school director for the Second Street Baptist Church. Sarah entered Maggie Walker's Independent Order of St. Luke.

In 1902, Sarah and Miles joined with other African American medical practitioners in their Jackson Ward home and office at 908 North Third Street to organize the Medical and Chirurgical Society. The group met each month to allow the city's black physicians to socialize and promote medical research in the community.

The Good Doctors

On May 11, 1905, Sarah Garland Jones, perhaps not yet forty, died at home. The cause of her death isn't known. Researcher and Medical College of Virginia graduate Betsy Brinson, PhD, inquired among older Jackson Ward residents who knew of Jones, but they knew little. "She seems to have contracted an illness," Brinson says. "Perhaps something in her chest; TB maybe, or cancer."

The Richmond *Planet*, which earlier had extolled Sarah, treated her passing in an intriguing manner. A two-paragraph summary on May 13 acknowledged her status as "the only practicing female physician of color in this state," and a "skillful physician who had built up a large and devoted patronage." The paper likewise refers to the Joneses' North Third Street house as "her palatial residence." This could have been a compliment for a woman of color's social achievement.

The obituary continues in detail that sounds odd to a latter-day ear: "Her complexion was fair and no one would have presumed she was colored. Her death will be generally regretted and her large number of friends will mourn her departure as a personal loss."

The Richmond *News Leader* reported, "Long before the hour set for the service crowds could be seen gathering at the church from all sections of the city." Eulogist Dr. George Ben Johnston (co-founder of Johnston-Willis Hospital) spoke of her as an able physician whose diagnoses were "invariably correct." The Reverend Dr. Lewis titled his sermon "She Has Done What She Could."

Richmond Hospital and Training School for Nurses, with fifty beds, was renamed in Sarah Jones's memory. Her will provided money to send her younger sister, Marie Jane, first to Howard University, then to study medicine at the University of Illinois. Janie, as friends called her, returned to Richmond and married Miles, who lived until 1931. She practiced obstetrics and infant care until her death, at ninety-four years, in 1963.

The Sarah Jones Memorial Hospital moved in 1932 to Overbrook Road. In 1945 it was renamed Richmond Community Hospital. Today, it is a 104-bed facility in Church Hill at 1500 North Twenty-eighth Street, in the Bon Secours consortium.

Originally published July 1998.

Richmond-Built Ships
The Trigg Yards

The tempestuous weather of October 31, 1899, didn't obscure the auspicious event scheduled for 3:30 that afternoon.

At the William R. Trigg Shipbuilding yards along the docks between Eighteenth and Twenty-eighth Streets, the United States Navy torpedo boat destroyer *Shubrick* was launched. President William McKinley and members of his cabinet arrived to witness the occasion. McKinley joined Governor Fitzhugh Lee and numerous state and national dignitaries on the dais, with representatives of the national press, while thirty thousand people crowded to see. The number of bystanders moved one writer to describe it as a merging "of several county fairs."

"It was the baptism of a new enterprise," the *News Leader* observed, "which, if all expectations are realized, is to play an important part in the destiny of this city and contribute largely to the extension of our navy."

"Our navy." The sentiment was key. Southern commerce and industry, in such persons as native Richmonder William Robertson Trigg, helped rebind the nation after the catastrophe of the Civil War. The businessman was fond of relating how, at age thirteen, he was captured by Union troops and then released because "he wasn't worth keeping." The ship setting sail that day, though, was named for a pre–Civil War South Carolina navy officer, William Bradford Shubrick.

Despite stiff winds and hard rains, the dockside along Chappel Island bristled with small craft burdened with onlookers while others clustered on rooftops. Boys clambered up telegraph poles for the best view. Vendors made a brisk trade of souvenirs, candy and peanuts. Coupons assigned for seating in the stand proved useless after police couldn't control the surging masses. Near the moment of the *Shubrick*'s christening, the steamer *Lou* sank

Richmond-Built Ships

Proud and smart-dressed Richmonders gathered on September 26, 1900, to celebrate the launching of the destroyer USS *Decatur*, one of the almost two dozen ships built by the city's Trigg Shipyards. *Courtesy of the Cook Collection, Valentine Richmond History Center.*

when passengers swarming too quick to one side of the boat heeled her over. Nobody was hurt.

After that excitement, the champagne bottle Miss Caroline Shubrick swung against the vessel's prow made an anticlimactic clunk and didn't break.

The 175-foot-long, 17-foot-wide torpedo boat, snapping pennants in bright colors semaphoring *Shubrick*'s name from the masts, eased down the ways into the canal. Uproarious cheering and a cordon of railway engines blasting their whistles met the moment.

Following this wet and blustery dedication day, the *Shubrick* served in various capacities through 1945 in both American and British fleets.

The ingenious and industrious William Trigg was descended from a distinguished Virginian lineage. He married Roberta Nichols Hanewinckel, daughter of the German consul to Richmond.

Trigg brushed against scandal as one of several designated witnesses for the May 9, 1873 duel between John B. Mordecai and Page McCarty. At issue were the affections of a belle, Mary Triplett. Mordecai lost his life, McCarty his sanity and the witnesses, including Trigg, were slapped in jail as accessories to murder, although they were all in time acquitted. Trigg

received a complete social validation when he was voted president of the exclusive Commonwealth Club.

He rose to the presidency of the Tanner and Delaney Engine Co. and employed his great energy to transform the shop. The company, renamed the Richmond Locomotive and Machine Works, was located at the north end of Seventh Street. The factory's three thousand laborers built the largest locomotives in the world.

Trigg's choice to embark on a shipbuilding venture surprised some of his peers. The Confederacy made ships in Richmond yards, but this was a necessity derived from adversity. Nevertheless, Trigg's considerable influence created a fledging shipbuilding company on Chappel Island.

Shipbuilding during the outset of the twentieth century was the equivalent of today's cutting-edge technologies in aerospace or information technology. The completion of the Trigg yards was as anticipated by Richmond then as a semi-conductor plant would be today. The successful *Shubrick* launching earned the company a $1 million naval contract, and five navy ships were under construction by 1900. The Trigg yards employed two thousand men and included fifteen buildings sprawling for a mile along the canal

The destroyer *Decatur* was launched on September 26, 1900. Young Chester Nimitz commanded the ship during 1907 cruises in the Philippines. He was court-martialed for grounding the *Decatur*, but outgrew his inexperience to command the World War II U.S. Pacific fleet. The *Decatur* continued service in Asiatic and Mediterranean waters until her 1919 decommission and scrapping in 1920.

Trigg's vessels included the navy cruiser *Galveston*; the *Samuel P. Lapsley*, a stern-wheeler missionary boat that plied the waters of the Congo River; and the Old Dominion Steamship Co. steamer *Berkeley*, launched March 18, 1902, with many in attendance, including "a large number of beautifully gowned ladies who graced the occasion."

The enthusiastic promise of the Trigg shipyard delivered almost two dozen vessels before Trigg's 1902 "paralysis attack," which might have been a stroke. His troubled health mirrored the company's accumulation of debt and failure to make payroll. The downturn of Trigg the man and his business were called a "public calamity." He died of kidney failure on February 16, 1903. The firm staggered into receivership and was auctioned July 10, 1905, for $368,000 to Philadelphia industrialists.

For years Richmond Structural Steel occupied some of the Trigg buildings. Subsequent development of the Great Shiplock Park uncovered the walls of Trigg's shipyard locks. Little else of the great enterprise remains.

Originally published March 1998.

The Unconstitutional Constitution
The Legacy of 1902

T he Virginia Constitution of 1902 caused half the state's electorate to lose the vote, in addition to codifying the split of cities from counties and restricting the governor from serving a second successive term. The document also established effective statewide apartheid and maintained political power in the hands of a few. Virginia thus entered the twentieth century shackled by provincialism, elitism and racism.

Vestiges of 1902 linger in law today, despite a successful 1970 overhaul. The chairman of the advisory commission for that 1970 extreme legal makeover was University of Virginia legal scholar and Richmond native A.E. Dick Howard. Howard explains, "The problem was the rather tempestuous nature of Virginia politics in the 1870s and 1880s. The [Democratic] conservatives saw wholesale buying of votes, mass corruption…[The 1902 representatives] saw themselves as rescuing Virginia from the temptations of gutter politics. Virginia was in an unstable mode—that was the best face. The worst face was racism."

Other Southern states had rewritten their constitutions with similar reactionary language, but Virginia came to it late. From the mid-1870s to the early 1880s, Virginia blacks served on juries and sat in both houses of the state legislature. Statute didn't regulate by race in most aspects of public society, although in certain situations integration was discouraged. The most glaring example was public schools. Attitudes hardened over time, particularly after the collapse of former Confederate Major General William Mahone's reformist (but somewhat opportunistic) Readjuster Party, built by an alliance between the poor and working-class whites and blacks.

By 1891 not a single person of color sat in the Virginia General Assembly. Charlotte County's Joseph R. Holmes, an African American, sought to run in 1892, but while making a speech he was shot dead by a white man. The

general assembly passed the state's first Jim Crow laws in 1900. Virginia's Democrats advocated for a constitutional convention. An underwhelming public referendum of May 24, 1900, cleared the way for the appointment by state lawmakers of one hundred delegates. The convention convened at the capitol on June 12, 1901. Deliberations continued for more than a year.

The convention's chairman was Bedford County Democratic Congressman John Goode. At seventy-two, he was a righteous old man who had served in the state and Confederate legislatures and the U.S. House of Representatives. Goode described black voting rights as "a great crime against civilization and Christianity." Former state Senator Carter Glass of Lynchburg (future architect of the Federal Reserve system) described black enfranchisement as "a crime to begin with and a wretched failure to the end." As Howard notes, "You can say this about Glass: he wasn't trying to hide the ball. He was forthright in his opinions. Everybody knew what the convention was trying to accomplish."

The convention was required to submit the completed constitution to a public vote. The delegates knew, however, that its provocative clauses wouldn't pass a referendum; thus the Virginia Constitution of 1902 wasn't voted upon, but proclaimed like a royal decree. It became law on July 10, 1902.

Afterward, voters were required to pay a "poll tax" (a tariff applied to all individuals, independent of their income) three years in advance of voting. Electoral officials in localities established their own requirements, including literacy tests that prevented many blacks and nearly a third of eligible whites from voting. By 1905, the number of Virginians voting was reduced to 50 percent of the number who had voted in 1901 and in 1940 just 10 percent of Virginians who were older than twenty-one could exercise their franchise. There were few legal challenges to the constitution. People then, as now, were busy earning a living and providing for their families. What would have otherwise been considered unconscionable became the accepted order of the day.

The political "machine" of Harry F. Byrd Sr. (1887–1966), governor and U.S. senator, thrived under these circumstances. The Byrd Organization that ran the Commonwealth of Virginia for half a century supported Massive Resistance, a strategy of opposition to racial integration. Federal civil rights legislation overturned race-based laws.

The Virginia Constitutional Commission of 1969–70 analyzed the document's flaws and detailed revisions. The commission included former Governor Colgate W. Darden, future Supreme Court Justice Louis F. Powell Jr., Hardy C. Dillard—who became chief justice of the World Court at The Hague—and civil rights attorney Oliver Hill.

The Unconstitutional Constitution

The 1970 constitutional changes didn't solve all the problems. "We're now fixed in a system that is terribly retrogressive for the state's cities," Dick observes. "They are locked without power to annex, and the counties do not share the problems of urban areas."

In hindsight, though, Dick is glad the Virginia Constitution was amended in 1970, rather than today. "The political environment is polarized and poisonous. It would be difficult to achieve a constitutional convention today. I'm not certain what the result would be."

Originally published November 2004.

"Let Us Walk!"
John Mitchell Jr.'s Trolley Boycott

On the evening of April 19, 1904, at 604 North Second Street, in the crowded meeting hall of the community's True Reformers society, banker and former city councilman John Mitchell Jr., the fierce editor of the Richmond *Planet*, stepped to the podium. Mitchell enjoyed speech making. He stood in his element with an audience cramming every available seating place and the stairwells. They wanted to hear this well-known man address a problem confronting almost every person in the room. Mitchell denounced the policy of racially segregating the trolley cars.

A recent statute passed by the Virginia General Assembly allowed but didn't require the separation of passengers by race. In Richmond, the Virginia Passenger and Power Co. decided to seat blacks at the rear of the cars and whites in front, beginning April 20, 1904. Mitchell insisted, "No act since the close of the Civil War has tended to arouse a more bitter antagonism."

Historian Ann Field Alexander describes a certain sense of conviviality in True Reformers Hall that night. Mitchell provoked laughter when observing that the "white men who mixed the races and gave up our crop of white Negroes didn't do it on the streetcars." Mitchell himself was not as dark-skinned as others and he wondered whether "white colored folks" would be forced to ride with the "white folks" or if they'd be made to wear tags identifying themselves as black. He proclaimed, "A people who willingly accept discrimination are not sufficiently advanced to be entitled to the liberties of a free people."

A resounding ovation meant affirmation. The boycott continued for nine months. Similar boycotts were attempted in other parts of the South, but were not as sustained as the one Mitchell led a half-century prior to Martin Luther King Jr.'s Montgomery, Alabama activism.

John Mitchell Jr. represented the success of Richmond's African American middle class, although Mitchell fought to correct a system that at one point allowed him to hold political office, then deprived him of the vote and made him sit in the back of the trolley. *Courtesy of the Valentine Richmond History Center.*

Mitchell announced through the pages of the Richmond *Planet*: "Let us walk!" The attitude was typical of him. He detested that Virginia's culture was divided even after the Civil War and constitutional reform. He and many blacks thought that the Old Dominion could lead the nation with progressive policies. As means for black advancement, Mitchell, at one time or another, supported African American advancement through education, social activism and financial independence.

An 1890 Indiana newspaper editorialist praised Mitchell as "daring to hurl thunderbolts of truth into the ranks of the wicked." The writer continued, "Clinging to no party, subserving no one interests save that of the oppressed, he throws the full force of heart and mind into every question that will affect the…welfare of his brethren."

Mitchell was born of slave parents, John and Rebecca Mitchell, July 11, 1863, on Henrico County's Paradise Plantation. This property was later the estate developed as "Laburnum" by newspaper magnate Joseph Bryan and was afterward the site of the former Richmond Memorial Hospital. Mitchell began his newspaper career by selling copies of the *State Journal* on Richmond streets. He distinguished himself at the Richmond High and Normal School at Twelfth and Clay Streets through notable talents in art and oratory. He taught in Richmond's schools until city regulations against black male teachers made it impossible.

Yale-educated politician Edmund A. Randolph founded the Richmond *Planet* in 1883, with several teachers and activists. The publication came into being amid this mistreatment of black educators. And so it was that when Mitchell couldn't teach, Randolph made him the *Planet*'s editor. Mitchell served in that capacity during the following forty-five years. The *Planet* grew—along with Mitchell's control—until Randolph tried to wrest it from him. The paper was sold at auction for $400 and was bought by Mitchell supporters who returned it to his leadership.

The Library of Virginia's Newspaper Project describes, "Under Mitchell, the *Planet*'s masthead, the 'Strong Arm,' was a flexed bicep surrounded by shock waves radiating from a clenched fist. Mitchell fearlessly reported lynchings, segregation and the rise of the Ku Klux Klan."

Almost the entire black population of the city responded to Mitchell's call for a boycott. Hundreds and hundreds walked. On weekday mornings, some whites complained of servants arriving cheerful but exhausted. Demands for witch hazel and fish salt increased for providing care to aching feet, and old bicycles were resurrected.

The boycott dissipated by early 1906. The general assembly passed a law requiring, rather than permitting, segregation on the trolleys. Virginia Passenger and Power would no more reverse its policy toward blacks than it

would to its own workers, whose 1903 protests of conditions and wages led to the mobilization of the militia to restore order.

The electric transit system suffered from both events. It was bought by New York monopoly interests, and then administered by a committee and taken out of Richmond hands. This and other complications led to the system's 1948 dismemberment.

At least one black Richmonder continued to boycott the trolleys. Mitchell, returning home by rail from a 1913 business trip, found himself without a ride to his Jackson Ward home. Rather than take the trolley, he hefted his luggage and walked the sixteen blocks.

Mitchell founded the Mechanics Savings Bank, administered the national fraternal order of the Knights of Pythias and ran for governor in 1921 on a ticket with business and civic leader Maggie Walker. The bank closed after charges of corruption (all later dropped), and political defeat disheartened Mitchell. He collapsed in his *Planet* office and died at home, 515 North Third Street, on December 3, 1929. Carl Murphy bought the newspaper in 1938, renaming it the *Afro-American and Planet*. That paper folded in 1996. The Richmond *Free Press* that has published each week since 1992 embodies the spirit of Mitchell's dedication.

Originally published March 1999.

Update: The Library of Virginia maintains an online exhibition about Mitchell and the Richmond *Planet*. A long-overdue and compelling biography of Mitchell, *Race Man: The Rise and Fall of the "Fighting Editor,"* by Ann Field Alexander, was published in 2002.

The Jamestown Imposition
1907's Virginia Celebration

The Jamestown Ter-centennial and Naval and Marine Exhibition ran from April 26 to November 30, 1907, in Norfolk. An event styled after the World's Fair and known best in public as the Jamestown Exposition, it was created to celebrate the three hundredth anniversary of Virginia's founding. The exposition fell far short of the 6 million visitors projected by its boosters and of the 2,850,735 persons who attended, fewer than half paid their way. The total debt, including repaying loans from the Virginia General Assembly, Congress and investment by stockholders, was $2,450,330.

The massive undertaking proved difficult to finance and produce and the site's overambitious buildings and giant pier weren't completed until three months before the exposition closed. Critics complained of crowded roads and instant villages that sprung up to accommodate workers and visitors; the spectacle was referred to as the "Jamestown Imposition."

The event suffered from mixed promotional messages. Was it a history pageant, a display of U.S. military and industrial might or an exhibition of varying cultural achievements? The attractions included seventeenth-century artifacts, modern warships of the United States and foreign nations and the exhibition buildings of twenty-one states in a 340-acre village of entertainment and education.

Talk of a three hundredth anniversary celebration began in 1893, shortly after the Association for the Preservation of Virginia Antiquities (APVA) acquired the northern end of Jamestown Island, site of the first settlement.

On February 5, 1901, the state legislature approved of Delegate George Wayne Anderson's joint resolution calling upon "all our sister States…if possible all the English-speaking peoples of the earth" to participate in a display of "the products of peace and the fruits of free institutions in all

the realms of human ingenuity." Virginia cities interested in hosting the event would present proposals to the legislature during its next session. The committee overseeing the Norfolk exposition proposed a union of all Tidewater localities to compete against Richmond.

Richmond civic leaders at one point suggested that the capital city should host an immense fair while Norfolk staged its massive naval and marine displays. The idea was dismissed as impractical. Even the Richmond *Dispatch* rallied support for the Norfolk location because, as one editorial explained, "Richmond has no claim to the celebration except her location on the James River."

The exposition committee bought a site on Sewell's Point for about $120,000. It was chosen because of proximity to all Hampton Roads municipalities. The December 1902 purchase caused a jump in land values between Norfolk and Willhoughby Bay.

Opening day, Friday, April 26, was attended by some forty thousand people, among them governors, congressmen, senators and diplomatic delegations from some twenty-one foreign nations. Hampton Roads was the scene of an international armada that included sixteen American battleships and vessels flying the national colors of Great Britain, Germany, Argentina, Brazil and Chile. The morning began draped in fog that lifted in time for President Theodore Roosevelt's speech, in which he denounced the power of large corporations.

Standard Oil tycoon Henry Huddleston Rogers arrived from New York City aboard his yacht *Kanawha* and was accompanied by his good friend, author and humorist Mark Twain. Twain was as popular a figure as any present-day television comedian-pundit, and throngs of fans paid tourist launches to take them into the waters of Hampton Roads in hopes of seeing the writer. The steamer *John Sylvester*, carrying 1,200 passengers, swerved close to the yacht while people on deck shouted Twain's name. He made a brief appearance, wearing a yachting cap and his white suit, to wave to his public.

When bad weather prevented the *Kanawha*'s departure to New York, Rogers and other members of his party returned by train, leaving Twain, who disliked rail travel. The *Kanawha* made it home with Twain aboard, but without any fanfare, and the *New York Times* speculated that he was "lost at sea." The incident inspired Twain to a little bit of satire, in which he wrote, "I will make an exhaustive investigation of this report that I have been lost at sea. If there is any foundation for the report, I will at once apprise the anxious public."

Not being drowned, he returned as guest of honor on Robert Fulton Day, September 23, to fill in for ailing U.S. President Grover Cleveland. The weather was dreadful, but Twain enjoyed himself anyway.

Famous visitors included African American leader Booker T. Washington (who wasn't allowed to eat at the exposition's restaurants due to his color), Britain's King Edward VII and publishing magnate William Randolph Hearst. The West Point Military Academy cadets came in June to perform their famous "Monkey Drill."

Though the "imposition" failed as a financial venture, its activity produced tertiary effects. Regional housing prices went up, and Norfolk grew northward. President Roosevelt decided to wave the "big stick" of his diplomacy, embodied by the Great White Fleet, by beginning its circumnavigation from Hampton Roads.

The visits by navy ships and commanders influenced the founding of the Norfolk Naval Base when President Woodrow Wilson (a 1907 visitor) took the United States into World War I. Indeed, many of the permanent structures left from the exposition became part of the base, including the former state exhibition "palaces" that contribute to present-day Admiral's Row. One award-winning commercial building designed by an architect named Frank Lloyd Wright wasn't as fortunate—it was demolished.

The beautiful exposition structures and the accompanying attractions were so well thought of, however, that some Hampton Roads officials asked that it be held again the next year.

Note: Robert T. Taylor's account in the *Virginia Magazine of History and Biography* was invaluable to this column.

Originally published January 2007.

A Complicated Woman
Novelist Mary Johnston

Margaret Mitchell, whose *Gone with the Wind* made her one of the most famous Southern woman writers, was frustrated when beginning her novel because someone else, she felt, had already mined the milieu.

She wrote in correspondence, "I felt so childish and presumptuous for even trying to write fully about that [Civil War] period when she had done it so beautifully, so powerfully—better than anyone can ever do it, no matter how hard they try."

Mitchell referred to novelist Mary Johnston, born November 21, 1870, in Botetourt County, Virginia, the eldest of six children. Because Johnston's health was frail throughout her entire life, her education for the most part took place in her father's well-stocked library.

John William Johnston, a former Confederate officer, held public and business posts requiring travels to Europe, New York City and Richmond. Mary took charge of the household after her mother Elizabeth's 1889 death. Financial necessity drove the writing of her earlier books, including those cited by Mitchell.

Johnston's first novel, *Prisoners of Hope* (1898), in which a mistress falls in love with an indentured servant, was produced to make money. But the 500,000 copies of 1900's *To Have and to Hold* made Johnston known and secured her finances. The novel was twice adapted for the screen, though in both cases for silent films, in 1916 and 1922. The 1916 version featured the screen debut of Mae Murray from Portsmouth, Virginia, who became known as "the Girl with the Bee-Stung Lips." Murray's long professional decline resembled Norma Desmond of Billy Wilder's *Sunset Boulevard*.

To Have and to Hold's fast-moving story, set in early colonial Virginia, concerns the plight of Jocelyn Leigh as she flees a forced marriage in England and is sold to a Jamestown settler. The plot involves attempted

Mary Johnston: novelist, social reformer, spiritualist, Richmonder. *Courtesy of the Homeier Collection, Valentine Richmond History Center.*

kidnappings, shipwrecks, pirates, ocean battles and Indians who plan to wipe out Jamestown. The high adventure of the novel compares to the recent *Pirates of the Caribbean* films.

Johnston produced twenty-three novels, thirty-eight short stories and one play. Her Civil War books venerated her father's memory, who died in Richmond in 1905, and assuaged the deep-held Southern part of her. *The Long Roll* (1911) was "vivid, crowded with pictures, full of detail," said one critic of Johnston's romantic but well-researched account of Stonewall Jackson's exploits. Then came the epic *Cease Firing!* (1912), embracing the entire war.

Dr. Edgar McDonald, emeritus professor at Virginia Commonwealth University, has studied and written about Richmond's constellation of early twentieth-century literati, including James Branch Cabell and Ellen Glasgow. In his view, Johnston deserves "a good, modern study."

McDonald says, "Her works, as corny as they may seem to a modern reader in many respects, are as relevant as Sheri Reynolds' *The Rapture of Canaan* or Sheri Holman's *The Dress Lodger*. Mary Johnston is a precursor to these writers."

Strong female characters acting within fanciful, even strange plots anchor Johnston's books. Though the settings are often archaic, Johnston's themes are contemporary. Her career, as critic Anne Goodwyn Jones says, was "long, prolific, and varied...[and] moved from historical romance to social criticism and then on to mysticism and radical stylistic experiments."

Betty Scott, a College of William and Mary graduate student, is editing Johnston's diaries of the 1920s and 1930s. "She wrote her entries very quickly, almost like telegraph sentences, like she was getting charged per word," Scott says. Johnston was busy: keeping house; visiting with novelist Theodore Dreiser, spiritualist J. Krishnamurti or the Glasgow sisters, Ellen and Cary; meanwhile always writing and lecturing. She spoke about women's rights, literature and spirituality.

She wrote of Richmond as only a true lover of it could, in an essay of the inaugural issue of *The Reviewer*, organized by several young, literary types who needed the credibility her name provided.

> *The infinite small and great conflict of wills out of which is woven drama—is it not plentiful in Richmond?...A whole Comedie Humaine might be placed in Richmond. I see a volume named Franklin Street and one named Grace, and one Clay or Marshall, and one Monument Avenue, and one Church Hill. One might be named Jackson Ward. The life of the coloured folk in Richmond awaits its delineator.*

Johnston died after a long illness on May 9, 1936, at Three Hills, the Johnston home near Warm Springs, Virginia. The large house was paid for by her writing income (and occasional lodgers) and is where she lived with her sisters. Three Hills is now a bed-and-breakfast. Mary Johnston is buried at Hollywood Cemetery.

Originally published September 2001.

The Richmond Dairy
"Milk Bottle Baroque"

S ince its construction in 1914, the Richmond Dairy Co. building at 314–322 North Jefferson Street in Jackson Ward has provided a unique niche for commercial, artistic and, of late, residential endeavors.

The respected architecture firm of Carneal and Johnston designed the building in a style architect and historian Robert Winthrop calls "milk-bottle baroque."

"You have this neo-Gothic industrial building with forty-foot-high milk bottles attached," Winthrop explains. "It's the only monumental-style dairy in the country that I am aware of. And it's Carneal and Johnston at their most eccentric." Additions of 1933 and 1946 were unimaginative.

The Richmond Dairy Co. building was headquarters for a prospering family business. In February 1890, dairymen J.O. Scott, A.R. Scott and T.L. Blanton formed the company. In a 1954 anniversary brochure, the company boasted of employing 389 people with an annual payroll of $1.3 million. A motor fleet served ninety-three routes in the city and its environs, extending to a thirty-mile radius. Dolly Madison and Richmond Dairy Ice Cream were distributed throughout central Virginia. Gray, then green, uniformed milkmen delivered milk, eggs, butter, creams and cheese to doorsteps and kitchens. The dairy retired its horses and began truck deliveries in February 1941.

Bernard M. Whitlow was a Richmond Dairy milkman from 1947 to 1952. At eighteen and a newlywed, Whitlow was assigned the West Franklin Street luxury apartment buildings and urban mansions. "It was a vertical route," Whitlow describes it. "I was jumping out of the truck and running up stairs the entire time." Whitlow enjoyed the route primarily because he was finished by 8:00 a.m.

On West Franklin Street, Whitlow organized orders and payments with servants and entered through alley doors. When he was transferred to Church

The Richmond Dairy. Perhaps the only "Milk Bottle Baroque" building anywhere. *Courtesy of the Cook Collection, Valentine Richmond History Center.*

Hill in 1950, he collected directly from family members on their porches. "You knew everybody; it was much more close-knit on Church Hill."

A milkman didn't just deliver. His official title was "route salesman." In order to drum up business and earn commission, Whitlow would walk in Church Hill streets ringing a hand bell to recruit new customers.

Whitlow recalls the constant sound of the dairy's machinery: the rattle of steel roller conveyer belts, the slap of wood- and metal-tabbed milk crates and the clatter of glass bottles. The air was heavy with the scent of hot pressurized water swooshing away spilled milk.

At the start of a shift, twenty or more of the reliable four-cylinder Divco Twin milk trucks parked in a line outside the dairy awaiting loading. A small restaurant at 312 North Jefferson Street, known as Jack's Sanitary Lunch and later as the Dairyman's Hideaway, served breakfast for the deliverymen as their trucks were being loaded. "You'd run out [from breakfast], move up your truck and maybe the five behind you, so those guys could eat, too," Whitlow says. "Nobody ever tried jumping ahead."

In May 1970, the modern convenience of chain stores and cardboard cartons forced the Richmond Dairy Co. to close. The property was auctioned off the next year.

The Richmond Dairy

The dairy building was purchased by Hanover investor Riley Lowe. But it sat vacant until August 1981, when for $475,000 it was purchased by Richmond lawyers Thomas F. Coates III, G. Ronald Grubbs Jr. and developer Alex Alexander.

The partnership envisioned a mixed-use business and arts-related enterprise, and by the mid-1980s the goal was to make the dairy a flexible arts center styled after Alexandria's Torpedo Factory. Some critics dismissed the concept as an "arts aquarium" for the benefit of tourism and not for working artists. Most than $1 million was spent on improvements, but disagreements with the city suspended the effort, though not Alexander's interest.

The dairy became studio and castle for sixty-four artists, woodworker Lenny Lancaster, sound engineer Ray Sparks, hat maker Ignatius, performance art/shock rock group GWAR, twelve to fifteen other bands and resident philosopher Ken Knisely, whose Richmond Philosophical Institute sponsored a BLAB-TV show, *No Dogs or Philosophers Allowed.*

Medical student John Sundin, who had served in Haiti with Doctors Without Borders, functioned as an informal dairy sexton. Russ Clem, a tee-shirt designer since 1969, was the "Great Short Father of the Dairy," who made sure rent and utilities were paid. "It was a dollar per square foot," Clem says, with a chuckle.

The dairy was an informal community of like-spirited people. The building was their sanctuary, even with its idiosyncrasies. Clem and artist Erik Fiks remember the intense cold and the rain drizzles that occurred on the third floor. Roof repairs were nearly constant. Sculptor Rig Terrell oversaw the restoration of a huge cap on one milk bottle.

"I'm a materialist," Knisely says. "I don't believe in gods and demons, but that building has a magical power."

"Many artistic spirits were delivered there," Fiks recalls. From the dairy's roof, denizens enjoyed the Independence Day fireworks from the Diamond, Dogwood Dell and Sixth Street Marketplace.

In late 1996, Alexander at last reached an agreement with the city to refit the dairy with 115 apartments, with medium income rent between $450 and $625, to encourage Jackson Ward's renaissance. The project, completed a few years later, cost about $8 million and some of it was generated through tax-exempt bonds.

Clem sees the development as part of a process initiated by the dairy's arts period. "Our presence brought people into Jackson Ward who wouldn't otherwise have come. This is the next step."

Originally published April 1997.

Emperor Gilpin
Jackson Ward's Dramatic Actor

In 1920, Richmond native Charles Sidney Gilpin was a New York acting sensation in the astounding play *The Emperor Jones* by Pulitzer-winning Eugene O'Neill. By 1930, the year he died, Gilpin had wandered into obscurity and silent, corrosive bitterness.

Described as "articulate, charming, hypersensitive and unstable," Gilpin for much of his life sought validation through the theater. What Gilpin once referred to as "that damned race thing—all about what I could do if I wasn't a black man" gnawed at his proud spirit. Despite his struggle toward and accomplishment of a high measure of success, the next great role never came.

He grew up at 922 St. Peter Street. Later, Richmond's first government-subsidized low-income residential development was placed there and received his name. The highway that was run through the middle of Jackson Ward took away the Gilpin house. The actor's contemporary and fellow son of Jackson Ward, entertainer William "Bojangles" Robinson, is assured remembrance through movies, a neighborhood statue and a popular song that is not about the Richmond "Bojangles." Gilpin got a project.

His father, Peter Gilpin, worked in steel mills and his mother, Caroline, became a trained nurse who worked at the Colored Almshouse. The couple raised fourteen children; their youngest was Charles.

The Gilpins practiced Roman Catholicism and Charles attended St. Francis School. Sister Jerome gave Gilpin his first acting instructions and encouraged him to play in the school's theatricals.

His formal education ended in 1890. At age twelve, he went to work in the print shop of John Mitchell Jr.'s Richmond *Planet* newspaper. Mitchell, an upward achiever with sturdy middle-class business sense, later recalled Gilpin's youthful character as the "wild sort." Gilpin hung around saloons

and theaters, making extra money by dancing and singing, then passing the hat. He got no glory from the experience, but he would remember that the street performing put him on the way of learning his craft.

Obtaining credentials in serious theater eluded most African American performers. The "stage Negro" prior to the Civil War was the creation of whites who "blacked up" in minstrel shows. These continued after the war, and sometimes even African American performers blacked up.

Gilpin and his mother moved to Philadelphia during the 1890s. The actor desired to hone his talents and find good direction. He acted in vaudeville and black stock companies ranging from the Perkus and Davis Great Southern Minstrel Barn Storming Aggregation to the Pekin Theatre of Chicago. He said of the Pekin, "Everything was attempted from serious drama to farce and I had a chance to develop."

After the Pekin Company fell apart, Gilpin went back to singing and vaudeville. He played characters for dramatic tension; the vaudeville managers wanted laughs. Conflict ensued and Gilpin worked as a day coach attendant on the railway.

In 1915, he cofounded New York City's Harlem-based Lafayette Players with actress Anita Bush and Dooley Wilson, who later played Sam, the piano player in the film *Casablanca*. This was a serious black theater. Critics discovered it. But during the rehearsal for a show titled *Paid In Full* scheduled for a March 1916 production, Gilpin walked out because of a salary dispute.

While with the Lafayette Company, he met his second wife, Lillian Wood Gilpin. His first wife was Florence Howard, whom it is supposed he married in 1897.

Like any actor who is out of work, Gilpin took up jobs where he could find them, as a barber, a printer, a railroad porter and an elevator operator. He appeared in some silent films with black casts and even made phonograph records due to his melodious voice.

In 1919, Gilpin landed the role of an aged black minister and former slave, William Curtis, based on Frederick Douglass, in John Drinkwater's *Abraham Lincoln*. This was Broadway. The show completed a successful run but by late 1920, Gilpin may have been running an elevator at Macy's. That was where George Cram "Jig" Cook, of the experimental Greenwich Village Provincetown Players, is supposed to have found him.

Cook hustled Gilpin to the theater and shoved a script in his hand. The play was *The Emperor Jones* by Eugene O'Neill, who had already won a Pulitzer for *Beyond the Horizon*. The role was that of Brutus Jones.

Brutus Jones is a former Pullman porter who has persuaded natives of a West Indies island that he is their emperor. The only way he can be

killed is by a silver bullet. A revolution erupts to overthrow his dictatorship. Jones flees into the jungle, where he must confront his fears, until at last his subjects find and kill him. The central character goes from a swaggering, Mussolini-style dictator wearing an ostentatious gold braided military uniform to a trembling, terrified wreck in a loincloth.

Jones is a huge and demanding role. The actor is onstage throughout the play, which in essence is one long monologue punctuated by a few interactions. There are also numerous costume changes with only a few lines of dialogue to cover the time needed to get out of one outfit and into another.

The play opened on December 27, 1920, and critic James Weldon Johnson wrote that "the next morning, Gilpin was famous." Reviews were incredible. One writer stated that Gilpin's acting had "transcended race and country."

Gilpin was invited to the annual Drama League dinner. The group hailed Gilpin as one of ten people who had contributed most to U.S. theater. But one of the membership objected to Gilpin coming, on grounds of race. The great John Barrymore is said to have remarked that rather than not have Gilpin attend the dinner, the entire membership should instead "black up."

O'Neill and others threatened a boycott and the disinvitation was rescinded. Gilpin came to the event, but he didn't enjoy himself. He also won the NAACP's Springarn medal and was *Crisis* magazine's 1921 Man of the Year.

Gilpin played *The Emperor Jones* 399 times in New York and then toured the show for two years. The production came to Richmond and played for three days after Christmas in 1921. Banker and social leader Maggie Walker and John Mitchell Jr. attended, sitting in boxes across from each other. In Richmond, superlative reviews in the white-owned papers were stigmatized by the inability to see past race. In one Western city, a black critic condemned the play as portraying "the worst traits of the bad element of both races."

Criticism mounted. Whites said the play proved that blacks couldn't resist the mystic pull of the jungle. Blacks were annoyed that it showed them as vain and superstitious. O'Neill also was free with the word "nigger," which was often said by his black characters. Brutus Jones uses it almost like a contemporary rapper. Gilpin started tinkering with the lines, excising the racial epithets and other words he found objectionable. O'Neill griped that Gilpin "played *Emperor* with author, play and everyone concerned." When on the road, O'Neill couldn't supervise Gilpin, and the actor altered the text to his taste.

Emperor Gilpin

O'Neill and the actor in time argued, sometimes with great violence. The playwright at last declared he was "off" him. Gilpin didn't take the show to London. That privilege went to a Columbia University School of Law student, Paul Robeson. His great talents would build a long career, and his social activism eclipsed Gilpin's trailblazing.

Gilpin spent the rest of his life searching for a vehicle to match his talent. He contributed money to the Karamu Playhouse in Cleveland, Ohio, and the company changed its name to the Gilpin Players in his honor. In 1926, he starred in the film version of *Ten Nights in the Barroom*, an anti-saloonist melodrama produced in Philadelphia by the Colored Players Film Corporation. By that time, Gilpin's depression and alcoholism were crushing his will and talent.

Gilpin returned to *The Emperor Jones*. In November 1926, one of those show business flukes brought to the Mayfair Theatre nineteen-year-old Moss Hart as Smithers, a Cockney English trader. The future writer of *You Can't Take It With You* and *The Man Who Came To Dinner* observed in his memoir that Gilpin was "limited not by his own range as an actor, but the limitations of the part the Negro could play in the theatre. Had he not been a Negro, there is no doubt that he would have been one of the great actors of his time."

After this production, Gilpin retreated with his third wife Alma Benjamin Gilpin to Eldridge Park, outside Trenton, New Jersey. His health deteriorated. In June 1929, he agreed to an *Emperor Jones* performance in Woodstock, New York, but in a last twist, his great voice gave out. He died on May 6, 1930. He was fifty-one years old.

O'Neill, as late as 1946, gave Gilpin his greatest compliment. He said, "As I look back on all my work, I can honestly say there was only one actor who ever carried out every notion of a character I had in mind. That actor was Charles Gilpin as the Pullman porter in *The Emperor Jones*."

Originally published September 1999.

A National Revival
Everything Has Played at This Downtown Theater

I *am* big. It's the *pictures* that got small," declares Gloria Swanson as Norma Desmond, the reclusive and deranged former movie star in the noir Hollywood tale *Sunset Boulevard*. The National Theatre, at 704 East Broad Street, shares a kinship with Desmond, having hosted the great and gaudy for long years, until its life suddenly halted, siphoned away to boxy multiplexes. The National, Loew's and the Byrd were intended to invoke fantasy, since not every movie was magical. They were called "atmospheric theaters." Moviegoing was a total experience including music, cartoons, a serial or two, perhaps a newsreel and the main feature.

The National, which in 1968 was renamed the Towne when managed by Neighborhood Theatres, sits empty but was saved from destruction due to the efforts of the Historic Richmond Foundation. The theater is near the proposed central city arts and entertainment district, intended to complement the improved convention and visitors' center.

It was designed by architect Claude K. Howell, who also created many Monument Avenue residences. "What's important about the National, and the Colonial next door, is their monumentality," says architect and historian Robert Winthrop. "Previous to these, most theaters were traditionally hidden away and part of large office builidngs." A prime example, the 1913 Lyric Building with its 1,500-seat theater, stood on the south side of Broad. Howell briefly made his office there; it was razed in 1963.

The theater opened November 12, 1923. One writer gushed that the National was "handsome, stately, adorned but not ornate." Ferruccio Legnaioli, who decorated the Empire and Byrd Theaters farther west and sculpted the Columbus statue, installed the appointments. Legnaioli's touches include nymphs throughout and a frieze of them near the roof line, nude and gamboling, shrouded by unspooling film reels.

The National Theatre is Richmond's remaining Broadway-
style house and since 1923 has featured almost every form of
entertainment, though most audiences have known it as a movie
house. *Courtesy of the Valentine Richmond History Center.*

The National replaced the Rex, which was built in 1909. Outside, it resembles an Italian Renaissance villa while inside it is a more restrained Robert Adams/Wedgewood style. Oval domes over the two-level lobby and the auditorium give an impression of palatial spaciousness. The theater could seat 1,114 people and included four boxes, still intact. The largest orchestra pit in Virginia could hold Professor Kaminsky's 25-member orchestra, an organ and a player piano. The building contains retail and office space; in its heyday talent agents like Herb Stone barked into candlestick phones to confirm the next booking. A billiards hall briefly occupied the basement.

While Historic Richmond carpenters were cleaning the interior, they uncovered a sealed nursery—a concession to parents who wanted a night

out but didn't want or weren't able to leave their kids at home. Along the walls are vibrant, painted stencils of children dressed as jesters dangling odd puppets from strings.

Governor E. Lee Trinkle and Mayor George Ainslie attended the first presentation at the National. It was a program of music and songs and a short film, *Her Reputation*, with synchronized accompaniment by the house orchestra. The stars were May MacAvoy and Lloyd Hughes and the movie's special effects included the breaking of levees on the Mississippi River and a forest fire. It concerned the plight of a woman defamed by irresponsible journalism. The last picture show at the National was Lou Ferrigno's *Hercules*, September 5, 1983.

The National's roster of performers ranged from vaudeville novelty acts like the *Mermaid in the Crystal Bowl*, Annette Kellerman, to the 1934 Broadway double bill of *The Barretts of Wimpole Street* and *Candida*. The casts featured a young Orson Welles, not yet renowned from *War of the Worlds* and *Citizen Kane*; Basil Rathbone of later Sherlock Holmes fame; and accomplished actress Katharine Cornell. Musicians who played there included Eddie Cantor, Fred Waring and The Pennsylvanians and the Paul Whiteman Orchestra, which elsewhere introduced "Rhapsody in Blue."

There were high-stepping chorines called the National Girls; a smattering of burlesque; revered radio personality Harvey Hudson hosted war bond drives; and there were always movies. Barbra Streisand's *Funny Girl* opened in 1968 with fanfare and spotlights.

In 1986, a wrecker's ball loomed offstage, and then Historic Richmond rescued the building like the cavalry in a John Ford western. Since then, a retired investment broker, Jim Whiting, and volunteers have tended and stabilized the old place. Its potential uses today range from the state's premier stage theater, a showplace for movies made here, a multipurpose corporate conference and entertainment center and even an ice rink. There is a parking deck behind it. While nothing public is brewing, the activity currently occurring downtown may yet spill into the National, at last restoring her reputation.

Originally published August 1993.

Update: Richmond-based RIC Capital Partners LLC purchased the National Theatre from the Historic Richmond Foundation in September 2006 for $1.6 million. The group, which is connected to the successful Norva concert venue in Norfolk, Virginia, put some $10 million worth of renovation and modernization into the building. The National is entering its next stage of entertainment history.

Branch Cabell and the Beast
Occultist's Admiration for Novelist

From the 1920s through the 1940s, Richmond fabulist James Branch Cabell (1879–1958) received a series of letters and the occasional book from "the Wickedest Man in the World," British occultist Aleister Crowley (1875–1947).

Cabell, a Richmonder, wrote influential fantasy fiction long before J.R.R. Tolkien. Throughout his fifty books, gods and goddesses borrowed from the world's myths and other ethereal creatures based in ancient stories or those he invented often interact with humans. Much of the action takes place in the fantastical French province of Poictesme.

Crowley, born into a wealthy Victorian family in Warwickshire, England, would today be termed a cult leader. In order to annoy his religious parents, he chose to call himself "the Beast 666." He formed the Argentum Astrum, or the Order of the Golden Star, and the Temple of Thelema as organizations to explore and expound upon his theories. Crowley was charismatic and persuasive. He practiced his own brand of "magick" and was obsessed by sex and altering the mind and mood through substances. Crowley adventured throughout the world, became a mountaineer and was a self-published philosopher and poet.

He declared that through revelation from an ancient Egyptian deity, a new era of thought was dawning, guided by the credo, "Do what thou wilt shall be the whole of the Law. Love is the law, love under will. There is no Law beyond Do what thou wilt." This meant act upon the dictates of your higher self, even though those still in the thrall of outmoded morality and laws won't understand you. Finding your innermost spiritual self, your divine aspect, is life's most important task. In other words, be all that you can be.

Cabell wanted to write "perfectly of beautiful happenings," and like his character Miramon in *The Silver Stallion*, "his taste in art was for the richly romantic sweetened with nonsense and spiced with the tabooed."

Novelist James Branch Cabell, a lifelong Richmonder, whose childhood home was demolished for the Richmond Public Library. His personal collection of books is in the Virginia Commonwealth University James Branch Cabell Library. *Courtesy of the VCU Cabell Special Collections and Archives.*

The July 1923 issue of the Richmond *Reviewer* literary journal published a fawning review by Crowley of Cabell's fiction, including Cabell's controversial 1919 novel *Jurgen.* Crowley declared,

> *We have had Homer and others to combine the affairs of gods and men in a single epos; we have had Balzac and others to combine the affairs of various families. But Cabell has done far more than either of these types of artists. He has taken the ideal forces of the Universe and shown their relations with mankind over a period of many centuries, from the legendary demigods of Poictesme to the inhabitants of present-day Virginia. He has set no limit to his canvas, and while every detail is exact and brilliant, it retains its proper subordination to the complete Idea.*

The hyperventilating hyperbole reads like a high school term paper, but Crowley's observation of Cabell's work is in essence correct. Cabell, who had an ego himself, appreciated the pleasing commentary, but Crowley's

attention was the kind he didn't need, given that some critics had accused Cabell of lowering society's standards of decency. Cabell dismissed Crowley as one of the "hordes of idiots and prurient fools...of dabblers in black magic" for whom he had little use.

The working title of Cabell's famous *Jurgen* was "Go to the Devil," and he somehow in his research found a volume that detailed the rites of Crowley's magic circle. He based a sex ritual in chapter 22 of *Jurgen* on such a description, not suspecting that the person who had invented it would write to him.

The New York City Commission for the Suppression of Vice banned *Jurgen* as obscene. The book about a pawnbroker whose wife is kidnapped by the devil and Jurgen's subsequent misadventures along the way to rescue her became an immense seller. It remains in print today.

Crowley noted the similarities to his ritual that Cabell called the Breaking of the Veil in *Jurgen*. Jurgen holds a bloodied lance against Queen Anaitis's upraised fingers that form a triangle. It is wink-wink, nudge-nudge humor that appalled upholders of decency in 1919 and intrigued Aleister Crowley.

Cabell wrote, "For Jurgen found that unknowing and proper form espoused Queen Anaitis, by participating in the Breaking of the Veil, which is the marriage ceremony of Cocaigne. His earlier relations with Dame Lisa [Jurgen's wife] had, of course, no legal standing in Cocaigne, where the Church is not Christian and the Law is, Do that which seems good to you."

Cabell kept a copy of Crowley's *Book of the Law* that Crowley had sent him. Cabell also possessed the 1952 biography *Crowley, The Great Beast*. Cabell didn't put a bookplate in the latter, nor is there indication he read it. He also filed away Crowley's letters and perhaps found them both odd and amusing.

"To James Branch Cabell," begins the almost illegible inscription in the *Book of the Law*, "in token of spirit and fellowship I, the Beast 666, offer this copy of the Book of the Law." Cabell actually returned the book to Crowley, but Crowley dutifully sent it again, and out of good manners, Cabell replied to Crowley that the material was too complicated for him.

Cabell and Crowley never met, nor did Cabell ever again reply to one of his letters. About a dozen of Crowley's occasionally insightful but mostly strange epistles to Cabell are on file in Virginia Commonwealth University's James Branch Cabell Library Special Collections and Archives.

Originally published October 2004.

Update: Cabell never recovered in full from his *Jurgen* success. Most of his other books, which aren't *Jurgen* but in some instances are better, remain obscure pleasures to the few readers who discover them by accident. His satiric fables have somehow resisted film treatment, but they show up in odd places. In Robert Stone's 1986 *Children of Light*, a dark treatment of the motion picture industry, the screenwriter protagonist Walker, in his early career as a playwright, "had written the book and lyrics for a very serious and ambitious musical version of *Jurgen* and been astonished to see it fail within a week."

The Place to Be
Forest Hill Amusement Park

You might have heard the orchestra of merriment before you arrived, especially if you were rambling along Forest Hill Avenue on a summer Saturday afternoon. Each attraction at the Forest Hill Amusement Park created music of its own.

The "tinkling, thundering" ragtime and classical tunes provided by the bellows-driven, mechanized calliope of the carousel; this perhaps could be heard underneath the roaring from the figure-eight roller coaster, called a Dip-the-Dip, and the excited screams of its riders; cries of barkers inviting the young men to win a doll for their sweethearts in a five-cent shooting gallery game.

You would also see the garish painted Forest Hill trolley easing into its station at the Old Stone House. Prominent Canadian-born attorney and businessman Holden Rhodes built the granite house, standing restored today, between 1836 and 1843. He called his 103-acre estate "Boscobel," from the Italian "bosco bello," meaning beautiful woods. The house underwent an 1890 transformation into the amusement park's welcome center. An incongruous bell tower was added, as well as a large wraparound porch. Underneath the porch were installed a number of distorting funhouse mirrors. Nearby was a nickelodeon where a patron would hand crank a herky-jerky moving picture, operating on the flipbook principle.

Monica Rumsey, who edited an informative booklet on Forest Hill Park written by Lynne Anne George, recalls how the eyes of a ninety-year-old lady lit up at the memory of the Stone House and its trolley stop. "Apparently, the young women would gather on the porch and wait for the young men to disembark and they'd watch to see which one they wanted to snag," Rumsey says.

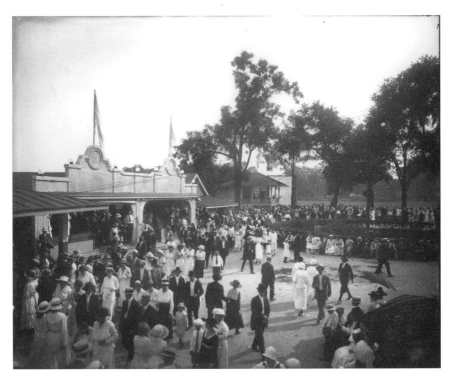

During pre–World War I days, Forest Hill Park was a place for families and young people to gather and pass a pleasant summer afternoon. And it still is, minus the rides. *Courtesy of the Cook Collection, Valentine Richmond History Center.*

Imagine their white summer dresses and wide hats with elaborate flower festoons, bows and pins. The ladies sat upon the balcony rails, waving hand fans and conversing as if not interested in the passing scene. The men, almost all of them wearing straw boaters or panamas, linen suits and seersuckers, stiff collars and dark ties, would glance toward the Stone House's porch to see who was pretending not to gaze their way.

Forest Hill Amusement Park evolved because of the electric streetcar system. The Richmond & Manchester Railway Co. purchased the electrical power plant, car line and equipment from the Southside Land and Improvement Co. for $150,000 on October 7, 1890. That transportation company saw the value of keeping people on the South Bank of the James River because of its sylvan setting, away from the crowded central city. Visitors often loved the area enough to buy a house there.

The amusement park's attractions included a bowling alley, a swimming area and bathhouse and a dance pavilion. By the mid-1890s, other diversions included a bicycle track and a stage for vaudeville performances. During

the first fifteen years of the twentieth century, the park was a primary social gathering place all year round. In the summer, there were after dark movies—quite an exotic attraction then—fireworks shows and fishing, and in winter the same lake became an ice skating rink.

The Great Depression made amusements less affordable. The park's equipment deteriorated. In December 1932 the Dip-the-Dip, carousel, airplane ride and penny arcade were dismantled.

Richmond today doesn't have an in-town, outdoor entertainment place where people might gather just for sheer enjoyment and exhilaration. The Canal Walk or Mayo's Island could use a Dip-the-Dip.

Originally published May 2001.

Lady Wonder
Chesterfield's Psychic Equine

Along Ruffin Road, a white hand-lettered sign once announced: LADY WONDER WILL SPELL AND SUBTRACT MULTIPLY DIVIDE TELLS TIME ANSWERS QUESTIONS. In a barn lived a scruffy, dark chestnut mare named Lady Wonder, whom some people believed possessed a few wild talents not often attributed to equines.

"Mrs. Fonda could get outright annoyed if anybody claimed it was mind reading or prophecy," Mrs. Julius Bokkon recalls. She was acquainted with the reclusive, frugal Claudia Fonda and her husband, Clarence, who owned Lady Wonder.

Bokkon was fresh from West Virginia and a newlywed when her family came to Chesterfield in the early 1950s. She insists that Fonda never said that Lady Wonder was psychic.

"She never tried explaining it, and she was definite when she said that it was for entertainment only and didn't take responsibility if someone took her responses seriously. Thing was, Lady was right a lot of times, and nobody could figure out why."

From 1927, when Lady Wonder predicted the outcome of a boxing match between Jack Dempsey and Jack Sharkey (Dempsey won), until a few days before her death in 1957, the lovelorn, investigators seeking clues, numbers players wanting an edge (Fonda refused them), journalists wanting a scoop and would-be debunkers trouped, sometimes by the hundreds a week, to ask Lady a question for fifty cents, three for a dollar.

Lady's responses came from a piano-sized, scrap-metal typewriter mounted on two rusty jacks that used a double row of keys topped by sponge rubber. When Lady nudged a key with her nose, a bracket released and a tin card popped up bearing a letter or number. The questioner was asked to shuffle the cards and slide them at random onto the brackets. Using

this method she made all kinds of predictions including, so the story goes, fourteen out of seventeen years the correct outcome of the World Series. When a group of students visited the Ruffin Road barn and asked the cube root of sixty-four, Lady Wonder without hesitation complied.

And if Lady Wonder wasn't enough, there was Pudgy, a piano-playing Pomeranian. The pooch would sit at an organ that had its legs sawed off, and according to witnesses, Pudgy could render a version of "The Bells of St. Mary's."

Bokkon recalls of Pudgy's keyboard skills, "You could even switch the pages of the music book, and she'd start playing that song."

Before moving to Chesterfield, Fonda was Claudia Koons of Utica, New York. She married Tredegar Iron Works machinist Clarence Fonda and they lived near trolley stop No. 9 off the Jeff Davis Turnpike. Lady Wonder was a foal bought for plowing from the nearby farm of C.E. Crowder. But, as Fonda later related the story, when she went to call the horse, Lady Wonder approached before she had uttered Lady's name. A coincidence, perhaps, except the horse exhibited the same behavior day after day. Mrs. Fonda fed the horse from a bottle and played with Lady Wonder like a child. One day Lady spelled out "engine" and a moment later a huge tractor chugged past the house.

The Fondas familiarized Lady with a set of alphabet blocks. She then graduated to the typewriter. Fonda had some experience, she said, in training Shetland ponies to accomplish minor tricks. For some time, Lady shared her stable with one of the ponies.

In December 1928, Duke University psychologist Joseph Banks Rhine and his assistant spent two weeks with Lady Wonder. Rhine was then formulating theories that would in time evolve into a peculiar branch of inquiry he called "parapsychology." He was also interested in the theory of inherited characteristics in animals.

While studying Lady Wonder, Rhine would write words such as Mesopotamia, Hindustan and Carolina on a paper, and keeping them out of sight, would have Lady spell them. Rhine concluded that at the very least some kind of psychological connection existed between Fonda and the horse. Rhine was followed by periodic visitors who never quite proved that either Lady or Fonda were psychic, or that they weren't. When Richmond annexed the Fonda farm in 1942, Lady Wonder received a license as an "educated horse" for fifty dollars.

Lady Wonder's reputation increased throughout the years as she predicted the outcome of sporting events, the entry of the United States into World War II, the nomination and election of President Franklin D. Roosevelt, math problems and the exact location of Mr. Bokkon's lost wallet. Lady

Wonder was as wrong as astute political observers when she predicted the victory of presidential candidate Thomas Dewey over Harry Truman.

In January 1951, four-year-old Donny Mason of Quincy, Massachusetts, was missing. Without clues, friends of the family visited Lady Wonder, who spelled out the boy's location as "Pit Field Wilde Water." The dragging of the Field-White quarry revealed the boy's body. And, in a conflation of *Green Acres* and the *X-Files*, Fonda claimed that Lady Wonder helped with other national cases, though she tended not to want to expose Lady to danger by answering questions about murder or kidnapping.

When Pudgy the Pomeranian was nabbed one morning and a $1,000 reward offered, Fonda said she got the identity of the dognapper from Lady Wonder, but Pudgy was not found. She told Bokkon, "You can't use the word of a horse to accuse anybody of a crime."

Lady Wonder died from a heart attack on March 19, 1957. Fonda wanted the horse buried in her and her husband's Maury Cemetery plot. This request was denied. Instead, Lady Wonder was given a modest memorial at the Henrico Pet Memorial Park and twenty-five people attended the funeral. Fonda died two years later. For a time, the Bokkons took care of Clarence, who in time moved to family in Pennsylvania and died some ten years later.

Bokkon went on to raise lion cubs for Meadowbrook High School to use as mascots and opened Goods In The Woods doll store. Her final appraisal of Lady Wonder: "I just think some things you can't ever know."

Originally published May 1997.

Richmond's Greenwich Village
Artists of the 1920s and 1930s

W hy do artists like Richmond? Here's what some of them have to say:

"You can think cheaper in Richmond. Maybe it doesn't do me much good to think. Anyway, when I have thinking to do I can do it more quietly and more cheaply in Richmond."

"You can find truer types here in Richmond. People here seem rooted to the soil. And when you stroll about the streets you come across types who could not have come from anywhere else but Richmond. It's like New Orleans that way...Sometimes the beggar you meet in the street will be as much a character as the man who's a power in the business world."

The time was 1936, and the anonymous artists interviewed by the Richmond *Times-Dispatch*'s Margaret Barker Seward were among those working and living in reclaimed old carriage houses and buildings along North First Street between Main and Franklin Streets, in the vicinity of Linden Row and the Richmond Public Library.

"This notion that the artist must starve and live in a rookery along with other queer birds has been all washed up," Seward quoted an art dealer as saying. "In the idea that in spite of what hard-boiled businessmen have said about their long hair and their fancy arithmetic the artist is an asset and as such should be cherished and that the mechanism of living made simpler and easy for him."

Premier in this circle of artists were colleagues Adele Clark (1882–1983) and Nora Houston (1883–1942). They were teachers, art advocates— missionaries, really—and champions of the women's movement.

Clark came out of Montgomery, Alabama, and New Orleans. Her family moved to Richmond in 1895. She studied in New York with famous "Ash

Can" painter Robert Henri and when returning to Richmond, committed herself to making not just art, but also a difference. She taught at various places and established the Richmond Academy of Arts, forerunner to the Virginia Museum of Fine Arts. Examples of her work are exhibited there today.

Josephine Estelle "Nora" Dooley Houston (pronounced HOW-ston), the niece of Major James Dooley, of Maymont Park, studied in New York City and Paris. Back in Richmond, she zealously pioneered modern painting and sculpture. Clark mentored her. Both women were active in Virginia's suffrage movement and the early days of the League of Women Voters in Richmond.

Clark gave notable service as director of the Virginia Arts Project of the Works Projects Administration (WPA), a federal Depression-era relief agency, and as a member of the Virginia Arts Commission (1941–64). She once stated, "I've always tried to combine my interest in art with my interest in government. I think we ought to have more of the creative and imaginative in politics."

Clark and Houston established the Atélier at 3614 Chamberlayne Avenue, a studio school where artists like Theresa Pollak refined their skills. Pollak went on to found what became the Virginia Commonwealth University School of the Arts.

The little portion of town near the Richmond Public Library was described in 1936 as "Richmond's Own Greenwich Village." These few Monroe Ward blocks attracted artists in the mid-1920s because the area was affordable. Here were six bookstores, two interior design firms and antique and furniture repair shops.

Richmond's artists were doers. Among those in Clark's milieu were portraitist John D. Slavin, whose subjects included President Harry S. Truman and the legendary actor John Barrymore; internationally recognized genre and landscape painter Oscar Giebrich, who held classes at 916 West Franklin (the Millhiser House on VCU's campus); and Berkeley Williams Jr., whose photograph in the 1936 article shows him mustached, wearing a beret and displaying a cigarette held in the tips of his index and middle fingers. He illustrated children's books. Anne Christina Fletcher worked in New York City and Richmond, traveled in Clark's orbit and also taught classes. At 110 West Franklin Street, in Linden Row, Richmond artist Elizabeth Dance kept her studio.

None of them became one-name famous, and some struggled with money in their later years, but the pursuit of art isn't for the weak willed. The romance of an often-wearying pursuit is bestowed in retrospect.

After Nora Houston's death in 1942, Clark continued teaching in schools, church classrooms and hospitals. She died at the age of one hundred on June 5, 1983.

Originally published September 2005.

World of Mirth
Traveling Carnival Based in Richmond

The funhouse mirror in front of the World of Mirth toy store in Carytown lures in the curious and kidlike, but it also honors a bit of history. The World of Mirth Shows carnival toured the United States and Canada from 1933 to 1963 with a train that could stretch from fifty to eighty cars long. Its travels began and ended in Richmond.

Frank Bergen and his wife, Hilda, owned the World of Mirth Shows. They lived in modest comfort at 203 North Pine Street in Oregon Hill in the 1930s, when Bergen listed himself in the city directory variously as a "director" or "showman." By 1943, the Bergens moved to upper-middle-class 4401 South Willetta Drive, behind Mary Munford Elementary School and between Cary Street and Grove Avenue. Bergen managed the business, and Hilda owned the custard concession always placed at the carnival's front gates.

"She never worked the stand, but she had it right there in front—she was the owner's wife," chuckles Bob Goldsack, who has written several self-published books about the traveling carnivals of his youth. HBO used some of his research as the network developed its recent series *Carnivále*. Goldsack's son-in-law and grandchildren appeared on the program. By the higher standards of World of Mirth, *Carnivále*'s ramshackle traveling show would have been considered "a ragbag" or a "40-miler," which were descriptions for a decrepit collection of amusements and freaks.

The World of Mirth maintained a stable northeastern route through the United States and Canada. It would run from Richmond to Ottawa, then return down the coast to Georgia before coming home. Its brightly painted orange train cars were adorned with drawings of the Earth.

"Carnivals carried a lot of shows," Goldsack says. "There were girlie shows, monkey auto races, midget boxing, bands; it was a whole world unto itself."

The carnival included magicians, singers, novelty acts, elephants, tigers and lions. Performers traveled or temporarily lived in the more than 130

World of Mirth artist Sal Taracina in his studio making masks for characters in the World of Mirth shows, while a leggy admirer looks on. *Courtesy of Ken Brown.*

show wagons. When the carnival set up at a new location, the wagons were hauled from the train into the center of the midway space and parked, and then elephants (sometimes twenty of them) would tow the wagons into their spot. Roustabouts hustled to unload and erect rides and tents. At the gate, a large sign was usually installed: WANTED: ONE HUNDRED MEN TO WORK.

The World of Mirth advertised itself as "the Largest Midway on Earth." Today, its rides likely wouldn't pass the rigors of an OSHA inspection. "There were no hydraulics in those days," Goldsack says. "Nobody pressed a button and it popped up; it was all dragged out and put together, whether it was raining or one hundred degrees. The workmen started Sunday morning and didn't finish until Monday at 4:00 p.m. You could see them sleeping under the wagons. It was quite something to watch it all unfold into a miniature carnival city."

World of Mirth quartered in Richmond at the old fairgrounds near where the Diamond is located. Here, passersby would see Ferris wheels, the Tilt-a-Whirl, the Tornado and the Flying Scooter. Once inside and past Mrs. Bergen's custard stand, patrons might visit Pallenburg's Wonder Circus,

Carl Lauther's Sideshow, the Penitentiary Show, Eddie Dyer's Monkey Show and, of course, the Penny Arcade. Young men could step into the Night in Paris Girl Show.

In 1954, the World of Mirth had contracts to visit fourteen fairs, but by 1963 it was down to eight. At the Ottawa Fair in 1962, a four-year-old boy fell from World of Mirth's Meteor ride, according to the Central Canada Exhibition Association website. He sustained minor injuries, but the boy's ten-year-old sister died attempting to save him. During the next year's Ottawa Fair, nine people were hurt after a car from World of Mirth's Kilimanjaro Ride rocketed off its track and smashed into the ride's control booth. The fair canceled World of Mirth's contract.

The carnival finally struck its tents in 1963, and its merchandise was auctioned off the next year. Frank Bergen died in 1971, Hilda in 1975. Little of this World of Mirth remains.

"Many of those show wagons," Goldsack says, "were used as chicken coops in the Richmond area." Wagon No. 12, which carried plates for the bumper car rides, awaits renovation at the carnival museum in Gibsonton, Florida.

Retailer Kathryn Harvey, who founded Carytown's World of Mirth, came up with her store's name from old posters she found while shopping for vintage items. "It just seemed to fit," she says. "We sure aren't Toys 'R' Us."

A little of the antic World of Mirth energy still lives.

Originally published September 2003.

Update: The Harvey family—Kathryn, her musician husband Bryan and their two daughters Ruby and Stella—died January 1, 2006. The Carytown store still operates and the sidewalk funhouse mirror is placed on the front sidewalk every day.

Dance Hall Days
Romantic Nights at Tantilla Garden

The name alone promised romance. George Arcy, a staff artist for Walter L. Coulter's Byrd Theatre Corp. that built Tantilla Garden, picked that name over the also lush Venetian Gardens.

In Latin, "tantilla" means "so small" or "a little bit." Arcy, according to a 1968 *Times-Dispatch* article, had seen a picture of an Argentinean House of Tantilla and he thought that the name sounded "pretty enough."

The hall at 3817 West Broad Street opened Thursday, June 17, 1933, in the bottom of the Great Depression, with the closest neighbors a horse farm and an orphanage. Tantilla Garden, poised at city's edge, was illuminated like an oasis in the surrounding night.

Advertisements declared it "the South's Most Beautiful Ballroom." Velvet swags, balconies and décor of burgundy, brown and gold and a polished dance floor demonstrated the claim. The long entry stair lifted patrons out of their everyday lives, through the Depression and World War II. The rollaway ceiling opened on hot, clear nights, allowing overheated dancers to feel transported to the moon on gossamer wings.

This wasn't Coulter's original plan. The $300,000 building was at first intended as an indoor golf range. That evolved into the twenty-seven-alley Tiny Town miniature bowling lanes, which was the scene of many birthdays and children's parties. Coulter, seeking greater revenue from his now empty second floor, made it into a dance hall.

The place and time jibed. This was the flowering of the Big Band sound popular with young adults. Duke Ellington, Tommy and Jimmy Dorsey, megaphone crooner Rudy Vallee, Fred Waring with his Pennsylvanians, Paul Whiteman, Sammy Kaye and Harry James, all of whom performed here, caused crowds, sensation and jitterbugging. Ozzie Nelson's band with lead singer Harriet Hilliard came. Hilliard entered through the hall's back

Outside Tantilla Garden, where couples could dance by the light of the moon. *Courtesy of the Valentine Richmond History Center.*

stairs to avoid clamoring male fans. Television soon enshrined the pair as Ozzie and Harriet.

Enthusiasm crested when a Richmonder among the famous performed. Hal Kemp brought Saxie Dowell, whose saxophone stylings were first heard at Byrd Park Pump House subscription dances. Buddy Morrow featured Richmond chanteuse Betty Anne Steele, who made "Mr. Wonderful" a hit, and Carole Noland sang with Les Elgart's band.

Tantilla's capacity was around 1,800 people and some 750 couples could dance together. Despite the music's excitement, decorum was maintained.

"Girls wore their best dresses and put on bright red lipstick and nail polish," a 1987 *Style Weekly* article noted. "Men dressed in coats and ties and the band members wore tuxedos." Friends gathered at tables on the mezzanine or the floor. Liquor by the drink wasn't legal, making "brown bagging" a preferred manner for enjoying spirits. Revelers brought a bottle and hid it in a bag underneath the table. Then, using setups of ice, soda or juice, revelers mixed their own drinks.

World War II servicemen stationed around Richmond were eager to attend Tantilla dances. Management's strong opinion that "local acts have no attention" fell when the war and draft dissolved the large touring bands. These regional acts included Babe Barnes and the Rythmaires,

Dance Hall Days

Guy Kilgore, Charlie Wakefield (a blind pianist), the Jimmy Hamner Orchestra with saxophonist Norman "Jeep" Bennett and the great Bill Zicakfoose with his Continentals. Dancer Pleasants "Snowball" Crump arrived, often unannounced, performing while the audience tossed money at his feet.

For a dollar the roaming photographer commemorated a couple's special evening. Kissing on the dark Broad Street balcony sometimes led to marriage proposals. When accepted, an announcement was made from the bandstand and the lovers danced at center to "Stranger in Paradise."

Stan Kenton brought his complicated, more listenable than danceable jazz to Tantilla, exhibiting how popular music and jazz were splitting. In the 1950s jazz greats Dave Brubeck and Maynard Ferguson played there. Tantilla's manager, C.B. Bishop, started booking rock acts on nights opposite the traditional dance bands.

During the 1960s Richmonders Tom Maeder and business partner Bob Collins, as Maeco Productions, brought to Tantilla "beach music," rhythm and blues and soul acts. The groups went by names like Bill Deal and the Rondells, Ron Moody and the Centaurs and the Tams (of "Be Young, Be Foolish, Be Happy"). Richmond musician Gary Gerloff experienced the Tams' show. He recalls it as an extraordinary moment of his life, "climbing the stairs of the Tantilla Ballroom…and witnessing the power of the Tams…propel and mesmerize the sold out dance floor." He'd never seen how "the authority of joyous, happy, big rhythm and blues music could hold sway over the crowd—that was a moment of transcendence."

In 1967 the eventual Richmond music impresario Chuck Wrenn helped orchestrate a proto-rave called the "Tantilla Psychedelic Beach Party," featuring the band Actual Mushroom. The show drew a capacity crowd of wild dancing "hippies." Wrenn remembers the event with a big smile. "Yes, sir. It was a sold out show that made no money. Thus began my brilliant career."

What should have occurred, like a changing passage of music, was Tantilla's rise as a regional music institution. "It could've been our Filmore, our Roxy," Gerloff says, with weariness. Maeder agrees, stating, "It's a travesty that it isn't there today."

Instead, citing a cost of up to $400,000 for renovations, management sold Tantilla to Home Beneficial Life Insurance Co. Gerloff paraphrases Joni Mitchell. "They really did tear down Paradise and put up a parking lot."

Tantilla's last dance came on March 22, 1969, with Babe Barnes and his Rythmaires. They played for 1,300 people. At 1:00 a.m., Barnes struck up "Auld Lang Syne." A careful, candlelit procession of white-haired patrons descended the long flight of stairs into a less magical world.

In 1989, the Richmond-born duo of Johnny Hott and Bryan Harvey, who formed the international touring House of Freaks, were living in Los Angeles and hating it. Homesick for Richmond, they titled their second album "Tantilla" and the cover photograph showed two figures walking on a rain-slicked sidewalk toward the dancehall's marquee.

The image evoked the longing and loss in the music and, according to Hott, "The name conveyed Richmond to us." As a youngster, he enjoyed the Tiny Town bowling alley. His father sometimes played on Tantilla's bandstand. Hott says that this connection to Tantilla made it seem "like somehow it still existed."

The impact of Tantilla exceeded "a little bit." While other venues rose, each commendable in their own way, none could surpass dancing under the stars at Tantilla Garden.

Originally published September 2002.

To the Lighthouse
Deco Diners

The Lighthouse Diners provided for travelers and residents of metropolitan Richmond a safe harbor from road weariness, hot meals, an honest cup of joe, a genuine smile and a waitress who might say, "All right, honey, y'all come back, now."

The diners numbered three. The first, still standing but dormant, is at 1240 Hull Street Road at the corner of Thirteenth and Hull Streets; the second and best known, 1224 North Boulevard, though altered is still recognizable; and a third, at 305 North Sixth Street between Marshall and East Broad Streets, is about in the Marriott Hotel's lobby.

The restaurants, with their large front windows, swivel stools, gleaming stainless steel and chrome and neon, distinctive cupolas and curving shiny overhangs, didn't have menus. The offerings and specials hung over the counters. Customers sat at the counter in two or three horseshoe-shaped bays—appropriate for a place called the Lighthouse. A grill served each bay with a refrigerator underneath for milk and butter. Regular customers sat in the bays served by their favorite waitress.

The Fosters—Earl D., Frederick J. and Lorne B.—inaugurated the Lighthouse chain in late 1949. The first stores were on Hull Street and downtown on Sixth. The Hull location included the company offices and bakery kitchens. The Sixth Street diner stayed open just a few years.

By 1960, only Lorne Foster remained on the management list. The business was sold to Dominic Gervasoni and his brother-in-law, Evan P. Shoemaker. Gervasoni came to Richmond in 1955 from Trenton, New Jersey, to assist Shoemaker in administrating the Cinderella Cleaners on Boulevard, next door to the Lighthouse.

Gervasoni worked for a time as a route manager for Seiler's Meats in Trenton. According to his son, Mark, who lives today in Bon Air, his father

This was the Lighthouse Diner at 1224 North Boulevard that, in recent years, has served as a medical supply store. *Courtesy of Dementi Studios.*

delivered meat to Albert Einstein in Princeton, New Jersey, and was present to watch the explosion of the airship *Hindenburg* at Lakehurst Naval Air Base. "My dad just seemed to be around when things happened," Mark says.

Mark Gervasoni's mother, Janet Keene, doesn't know why the Fosters got out of the diner business. "They just chose to sell," she says. The bustling laundry was close by and adding a diner to the mix seemed like a good idea. Mark Gervasoni remembers how as a child his father always in an apron with his white shirtsleeves rolled up and Shoemaker was in his coat and tie.

"My father was there at some ungodly hour in the morning and he worked all day, but he was always home for dinner," Gervasoni says. "Then he'd go back to the restaurant and work until late. My dad's work ethic was just unbelievable."

The Lighthouse wasn't an "all night diner" but a "24 hours a day, 365 days a year, 7 days a week diner," as Gervasoni describes it. "Some of our customers, especially on Hull Street, wouldn't let us close on Christmas, otherwise they'd have nowhere to go," Keene says. "We'd close late on Christmas Eve night. We had people who ate there three times a day, especially on Hull Street. I guess they came to us so often because some people lived in rooms and maybe they didn't have kitchens. People really depended on us. We had faithful customers."

Likewise, waitresses who knew their customers well might store their favorite jam in the fridge, in case a delivery wasn't made. "The waitresses doted on the customers, because, you know, the tips were better that way," Keene explains. "But we did great business, on Boulevard and Hull Street, all the time."

A short period of discomfort came in the early 1960s when restaurants integrated. "Hard to believe now," Keene says. "But we had waitresses who wouldn't serve black customers if they came in. We had to watch them and make sure they did. We had some small problems like that, but we got through it."

The Boulevard location hopped more during baseball season, because of the proximity of Parker Field. "We served breakfast all the time, but dinner, too," Keene says. "We were the biggest coffee distributor in town in those days; I remember the coffee salesman telling us that we used more than anybody, I guess because we were open all the time."

Dominic Gervasoni cut his own meats, making hamburger patties and steak, as he'd done for Seiler's back in Jersey. His son remembers getting led by his father into the back of the Hull Street store to eat hot cookies as they cooled on the rack. "Right out of the oven," he says, "and they were good. I guess that's a big difference; this was before everything was pre-packaged, freeze-dried and microwaved. And you can taste the difference." The fresh breads and meats were trucked to the Hull Street store. Gervasoni watched sign painters emblazoning a Chevrolet delivery van with the Lighthouse logo.

Gervasoni, as a young boy, could barely peer over the counter and observed underneath the one at the Boulevard store "hundreds of pieces of bubblegum, hardened in place." The waitresses always treated him and his brother well. "They were great ladies. It was a wonderful place to grow up. And when my father died [at age fifty-two, of stomach cancer, in 1967] the outpouring of compassion on their part was tremendous."

Shoemaker kept going a while longer with Del Hogy and William E. Goodliffe, both also involved with the laundry business. Then Shoemaker and his wife parted, causing a rift in the cleaning chain. Her laundry retained the name of Cinderella and his became Four Seasons. By 1975, the Boulevard store was the last Lighthouse shining. It was managed for a time by Frank Manns and finally Reggie Johnson and Chip Wilson.

The Boulevard Lighthouse was in time bought and stripped of its character, then leased by Moto Europa, an import motorcycle shop specializing in the Ducati that later moved down the street. The Hull Street Lighthouse retains its cupola and shiny metal marquee. Perhaps one or both

of the Lighthouses will ultimately return to their prior business, every day, all day.

Originally published March 2000.

Update: The Prodigy Partnership (composed of regional investors Jim Kennedy, Hayden Fisher, Mike Hanky, Jake Crocker and Patrick McLynn) is reviving the former Lighthouse Diner at Hull and Thirteenth Streets, with plans to revive it as a vintage diner to include a museum showcase. The remainder of the building is to be devoted to a "West Coast–style" food and entertainment experience with an interactive audio-visual component. Other aspects are to include a rooftop deck with a small kitchen, a full-service bar and a small garden to provide the restaurant with fresh vegetables.

The Wizard of Wythe Avenue
Louis Rubin's Weather Forecasts

Long before Double Doppler was a twinkle in John Bernier's eye, Louis
Decimus Rubin, a retired appliances salesman and contractor, gave
weather predictions accepted as near-gospel by Richmonders.

From the 1950s until his death in 1970, Rubin issued his Rubin Day
forecasts, days when local weather was supposed to turn cool or stormy as
a result of volcanic ash whirling in the atmosphere. Many Richmonders cut
out the information boxes from the Richmond newspapers for reference.

He believed that volcanic eruptions are the earth's reaction to sunspots,
which are cooler, dark spots with geomagnetic properties on the surface of
the sun. The sun's energy irritates the earth's interior until volcanoes blast,
Rubin said, which professional meteorologists disputed. Ash, spewed into the
upper atmosphere, follows the rotation of the earth in a predictable, westward
direction and filters the sun's rays, thus reducing ground-level heat.

Monitoring volcanic activity from around the globe, Rubin predicted
cool temperatures and storms—but not hot weather. He also forecast
earthquakes using data from sunspot activity. His daughter, Joan Schoenes,
says he correctly checked off some major shakes. "He got the Nome, Alaska,
one," she says of the Great Alaska Earthquake of March 1964, which at
9.2 magnitude stands as the largest temblor recorded in North America.
In 1960, he also foresaw the world's most powerful recorded quake, of 9.5
magnitude in Chile.

Schoenes says that her father wanted to bequeath his earthquake-
prediction equations to future generations. "He said he'd leave everything
in a safe deposit box with my name on it," she explains. "But after he died,
I went to the safe deposit box and opened it and it was empty."

Rubin grew up in Charleston, South Carolina, and dropped out of school
after his parents' health failed. He married a Richmond girl and worked in

Louis D. Rubin (center) explaining weather predictions to Woman's Club members
Mrs. T.G. Barber (left) and Mrs. William Craig (right). *Courtesy of the Richmond* Times-
Dispatch *Collection, Valentine Richmond History Center.*

his Charleston electronics business until brain abscesses immobilized him. The family moved here so Rubin could be treated. He underwent seven operations during a two-year period in the 1930s.

Louis Rubin Jr., who founded Algonquin Books of Chapel Hill, North Carolina, recalls that his father's interest in meteorological events incubated while he convalesced at Memorial Hospital on East Broad Street.

"My father had little to do but look out the windows and watch cloud patterns," Rubin wrote by e-mail. "His interest in weather predicting goes back before then, for there are photos of him in his office in Charleston in the 1920s…with his recording barometer prominently displayed."

One of Rubin's hobbies—an obsession even—was taking notes and photographs of cloud formations. He became expert in how their movement and size indicated daily weather patterns. His color photographs were used in three encyclopedias and seven science textbooks. They also illustrated his posthumous 1970 *Forecasting the Weather*, revised with the assistance of Channel 12 meteorologist Jim Duncan for a 1984 reprint as the *Weather Wizard's Cloud Book*. It remains in print today.

Rubin was making his weather forecasts public for five years when he rated a profile in the March 22, 1956 Richmond *News Leader* headlined "Wythe Ave. 'Wizard' Worries Weathermen." Rubin claimed 80 percent accuracy. "Others," according to a 1991 *Times-Dispatch* retrospective, "calculated his success rate at 39 percent on the average and as low as 11 percent."

But Rubin thought he was predicting the weather and if Richmonders didn't believe it, they at least used his forecasts, with a grain of salt, as a hedge against the future.

The calculus for forecasting storms and cold weather came into the hands of Schoenes. Did the Rubin family themselves adhere to the warnings of a Rubin Day?

"No," she chuckles. "We didn't plan around them. We kept them in mind, you always hoped. We'd dash for the calendar to check. If the Rubin Day proved correct, then it was score one for Dad."

Originally published August 2006.

WGOE
"One Station Underground"

O n October 25, 1971, radio promoter Dave Dewitt writes in his journal,

> *Snugly nestled between Dick Strauss Ford and the Bonanza Sirloin Pit lies the studios and offices of WGOE—in an incredibly small, glass-enclosed building which originally was the used car office for Ward Volkswagen.*
>
> *"We've even thought of moving across the street into the vacant Hungry Penguin Fish and Chips building," observes E. Michael Murray, station manager. "I'll consider anything to get us out of this dump."*

Dewitt believes himself fortunate to have this position. He blew into Richmond after a stint in the rural Deep South selling radio bingo. The money was good, but the ranking of sales stood just above con man. Now he had landed in the middle of rock and roll, at 1590 on the AM dial: "The highest you can get on your AM radio."

Dewitt considers that he's allowed more creative freedom than he expected. For Dewitt, the station "is an incongruity—location, personnel, and past history."

And then things started to get weird.

The station's on-air personalities—John Stevens, Jay August, Doug Stell, Jim Letizia, Les Smith, Ken Booton and others—became voices plugged into a perceived cultural revolution. It was a daytime-only AM aural psychedelic assault on conformity.

F.T. Rea, an observer of Richmond's fits-and-starts counterculture, was manager of the Biograph Theater that advertised on WGOE. Rea once stopped at a Fan traffic light and not only heard the station blaring from several nearby car radios but also turned to see everybody laughing at the same wacky commercial.

"It was a remarkable little episode in a strange time," Rea remembers. "The station gave the young people an odd, communal feeling. You turned on your radio and you never knew what was going to happen next, it was happening right there. It really was the last time an audience could be that connected to a radio station."

Dave Russlander, who did weekend shifts at WGOE between 1973 and '74, has a sardonic take on the past. "We had a pretty good listenership, depending on how long the day was. A lot of people weren't in touch with the kids, and we were, because we were them."

"The Sixties," and the freighted connotations the phrase carries, arrived on Richmond radio, spurred on by the late-night *Ugly Show* on VCU's campus radio station, managed by Jerry Williams, later a regional film and television commentator. The *Ugly Show* begat John Stevens, Les Smith, Doug Stell and others who graduated into GOE. Stevens inaugurated *Saturday Subway*, playing progressive music, on a traditional-style station that first signed on in 1964 with Jess Duboy and "Gentleman" Jim Granger at the mikes. Then, WGOE played Henry Mancini and The Beatles.

But the times, they were a changin'.

Murray went away for one odd weekend in May of '71. The deejays, in his absence, in a fit of whimsy decided to ditch Top 40 in favor of the music *they* liked. Thus, GOE became "One Station Under Ground."

"It was like a be-in," Stevens, now a popular daytime deejay for Philadelphia's top-rated FM music station WMMR recalls. "But the format change was very false. Ken Booton quit on the air. Jay August quit on the air. We'd play 'Knock 3 Times' by Dawn, or something real cheesy, and say, 'They're making us play this, we don't like it!'"

Belt Boulevard closed to traffic. Channel 12 sent a camera crew. Scores of hippies trailing clouds of petitions as they came urged The Man-agement to banish Top 40.

Dewitt was appalled by the event. "It was a great publicity stunt but my clients were furious. I was selling advertising at what was a standard Top 40 radio station and now overnight it wasn't anymore." In a dizzyingly short time, the station rocketed from the bottom of a thirteen-station market to fourth.

But Richmond remained a conservative business community. At radio broadcaster functions, the GOE delegation arrived wearing sandals and tie-dyed shirts into a room of suits and ties. They may as well have been from the land of Honah-Lee.

"Ken Booton (aka 'Melvin the Green Frog'), the morning guy, would tape the other guys, like Alden Aaroe," Dewitt says, "and play it back and yell, 'You'll never hear this on GOE!'"

"Our slogan was, We Gross Out Everybody," tells Les Smith, a weekend deejay, now with the Virginia Museum's educational outreach program. He played "strange stuff" during his tenure at GOE, October '72 to May '75—13th Floor Elevators, Mothers of Invention, Pink Floyd, Jefferson Airplane, Grateful Dead. Then they were all new, exciting and it was Richmond pre-FM and nobody could believe it.

"There was a whole lot of music out there that they just weren't playing," Smith says. "It was a chance to educate the audience." Smith and his colleagues approached their work as deejays with an artistic sensibility. "We weren't just picking up records out of the new music bin. The deejays I listened to, and the one I wanted to be, was somebody who could build a show with texture. Start off strong, but shape it, mold it, so there's a style, beat, mood, sometimes the music might have related themes, sometimes, it somehow made sense because of the sound. Our audience could dig that."

Smith jokes that he was told, "Les, you're weird, you have to do weekends—and you have to interview KISS." He didn't know much about the loud, over-the-top group, so he enlisted the aid of music enthusiast Buzzy Lawler. Together they met Peter Criss and Paul Stanley, both of whom wore none of their trademark makeup or costumes. "And it was one of the most interesting interviews I'd ever done," Smith recalls. It was engrossing enough not to run commercials or the news.

In the early days, J. Michael Graves delivered news that he based on UPI wire reports. He concocted elaborate fifteen-minute programs using the real news, sound effects and flawless delivery. Sometimes he broadcast from the roof of the studio. One day, fans, urged by Stevens, arrived to pelt the surprised newscaster with eggs. An overzealous participant tried hefting a watermelon. Graves used this busted melon to exact revenge on Stevens by shoving it over his head.

Since the Bonanza Sirloin Pit was next door, for lunch the entire crew would on occasion adjourn there, leaving an album playing, locking the door and toting a transistor radio to monitor the station. "This was of course terribly illegal," Stell says. "And sometimes a record would get stuck and somebody would have to beat feet inside to correct the problem."

Also illegal were the midnight firing-up parties where the deejays simply turned on the transmitter to calibrate the transmission and instead played music and acted, well, like deejays. "Our wave would bounce off the ionosphere," Stevens remembers. "We got requests from Boston, Cleveland, Philly."

Among the many artists whose concerts the station promoted or who dropped by the studio for interviews, or "unplugged" concert sessions as they would be called today, were Frank Zappa, Cat Stevens, Alice Cooper,

Black Oak Arkansas, Linda Ronstadt, Audience, Glass Harp, Traffic, J.J. Cale, Leon Redbone, Rod Stewart and Faces and Sha Na Na.

The Richmond Arena often held GOE-sponsored concerts. There were no seats, so people lay on blankets. The sound was for the most part acoustic. In February of '72 Stell saw a show featuring Country Joe MacDonald (Woodstock: "Gimme an 'F'!"), Jesse Collin Young (Youngbloods) and an impressive female pop artist on the brink of fame named Carly Simon. "Nobody knew her, really," Stell recalls. "She sang, 'That's The Way I've Always Heard It Should Be.' Later, she came to the front of the stage, no retinue, she was extremely nervous. And she was *tall.* I remember this vividly because it was a Friday night eight weeks to a day before I left for the Coast Guard."

WGOE was not prepared for its success. The youthful staff and the tenor of the times combined to form a mercurial method of conducting business.

"We were scamming and jamming in those days," Dewitt says.

He was taping a promotion when a flustered secretary knocked on the door, urging him to come out. He was busy. She insisted. When he answered the door in anger, she said, "The FCC is here. I think you should talk to them."

The charges ranged from false power readings, rigged contests, graft and corruption. An embittered employee had blown the whistle. A series of investigations dragged on from the spring of '72 to '73. Dewitt was placed on the stand to testify concerning the double billings of advertisers. He told the court that nobody at the station really knew what they were doing.

Meanwhile, WGOE's studios moved to the lobby offices of Lexington Tower, downtown. The station's free form and antic character continued, even as personnel shifted, but according to Dewitt the mood had mellowed. "We'd been busted," he says. "It was like Nixon after Watergate."

At about this time, Peter Coughter, the station's media director, who went on to become a part of Siddall Matus and Coughter advertising, arrived on the scene as the station's movie reviewer. Coughter "was into biker movies, B-Movies, anything with Pam Grier in it. Couple of times we even made up movies that never existed and I cast my friends in them, talked about them as if they were real."

Coughter also had the odd responsibility of making movies for showing at clubs where GOE deejays were in charge of music. He filmed Bruce Springsteen, a skinny, whispy-bearded kid in painter's paints, playing with the E Street Band at Alpha Audio during an on-air acoustic session. "Unfortunately, there's no sound," Coughter chuckles.

Frank Zappa dropped in, right about the time of "Overnight Sensation." Smith and Letizia interviewed him, but Smith in a rueful way recalls it as

a "very bad interview." Zappa arrived in stacked heels and tight clothes, "looking more KISS than KISS," Smith says. Coughter spent time conversing with Zappa, sitting on the office floor, where Zappa revealed that his favorite movie was *Spiders from Mars*. Stevens did a short tour with the Mothers of Invention, from D.C.'s Cap Center to Richmond. "It's probably true that nobody ever drove a band as hard as him," Stevens says, "but he was one helluva musician and an incredible person."

Everything turns, and the season that brought WGOE into prominence began fading, like a distant station carried on the car radio late at night. FM stereo arrived in force with WRXL and WRVQ. The brief hiatus of sensibility concluded, dissolving into corporate structures, demographics and narrow casting. During the late 1970s and early '80s WGOE switched owners and managers, tinkered with format and in the end renounced its previous call letters.

Dewitt quit the station and moved to New Mexico, where he writes and does extensive voice and camera work. He edited the successful *Chile Pepper* magazine and today publishes about, and maintains an Internet presence devoted to, fiery foods. Stevens rocks Philly. Russlander became the data processing coordinator for the Senate of Virginia. Letizia and Booton have passed into the mystic. Now, 1590 AM is a gospel station. Of GOE, little remains besides tee-shirts, memories, yellow adhesion signs and, on a few surviving mid-'70s cars lumbering around town, a bumper sticker: WGOE: DEATH OF AN OLD FRIEND.

Originally published March 1994.

Update: WGOE's style was succeeded in some respects by Color Radio (1982–84), which was heard behind Continental Cable television's color-bar test pattern on Channel 36. A phone line carried the feed from a makeshift studio above Plan 9's Carytown record store to Continental, which broadcast the signal. The deejays were invited volunteers, who included musicians. They played and said whatever they liked.

The community-based, volunteer-driven and FCC-compliant low-power WRIR 97.3 FM got to air in 2005 after twelve years of effort. And RIR's deejays just about play anything.

A new Internet, Richmond-based station for blues and Americana music is reclaiming the WGOE letters.

RAW and UAA
Taking Art to the Streets

Two walls in Shockoe Bottom, the first on the side of the Main Street Grill on Seventeenth Street and the other in Walnut Alley, bear witness to the legacy of two dynamic Richmond art collectives whose alumni continue to enrich the region and the world beyond the James River.

The Richmond Artist Workshop performed and exhibited from 1976 to 1982; Urban Artists Amalgamated produced mixed media presentations from 1987 to 1991. These cooperatives shared similar views in bringing art into city streets and alleys. RAW created the folk life mural of Farmer's Market life on the Grill's wall. It has survived three floods. The handiwork of UAA members, with self-portraits of artists, is around the corner.

"It's ironic, but places where we showed, like Franklin Street Gallery don't exist anymore—but what we did in the street is there," says poet Karen Falkenstrom, a cofounder of UAA.

RAW and UAA, combined with the presence of the artist-run 1708 Gallery and Artspace, among others, drew people into Shockoe Bottom and helped it evolve into a vibrant urban environment.

RAW started in 1976 as ideas were discussed in the homes of artists and musicians about forming a community arts group. "When you're young, you think, 'The more the merrier,'" musician Danny Finney recalls. In those far off, pre–e-mail days, getting people together meant handbills.

Finney describes, "We put forth a flier, gave it to every artist and musician we could think of, and about 140 people showed up for a mass meeting in Monroe Park." This was Sunday afternoon, September 5, 1976.

For two years, the diverse membership met in each other's houses. "RAW was strongly associated with the Oregon Hill Food Cooperative and the movement to save the neighborhood," musician Barry Bless explains. "It

was an experiment in local cultural self-reliance and the proposition that art is local resource in the same way as water, soil and capital."

Bless's father, Wally Bless of the Main Street Grill, made available 1717 East Main Street. "Wally was our patron saint," Julian Jackson, a RAW curator and now an artist living in Brooklyn, remembers. "He just radiated good energy." True to the name, 1717 was a raw space, seventeen feet wide and eighty feet long, but it provided a home. "Wally said we couldn't paint over his paneling, so we hung up burlap and painted on that," Jackson says.

RAW incorporated, held meetings each month, had lengthy discussions about its purpose, published the Raw-o-gram newsletter and struggled to support itself. RAW members staffed the Grill two nights a week, and money was parlayed into the organization.

Political activism was a fundamental part of RAW. A post–Three Mile Island nuclear power exhibit "Attention! Attention!" converted 1717 into a "vision of a potential apocalypse," as Jackson describes it.

Jackson and his wife Rene Lynch curated RAW's presentations and they were succeeded by Holly Sears and Jim Luton. "It was a time when the alternative arts weren't yet institutionalized," Jackson explains. "And we were really trying to decentralize the New York arts scene by bringing these groups and the arts into areas where they weren't expected."

Jackson and Lynch put together some twenty shows during their stint. "And we did RAW, and Rene and I showed at the Virginia Museum; we were ambitious artists and, well, ended up in New York with Jim and Holly."

Music was an important component. Among the acts that played in RAW's space were Eugene Chadborne, saxophonist John Zorn, violinist Polly Bradfield, trumpeter Leslie Dalaba, Japenese trumpeter Toshinori Kondo, Italian percussionist Andre Centazzo and the weird 1/2 Japanese (since subject of a documentary).

The Main Street Grill and 1717 East Main Street became known around the world as venues for the avant-garde, at a time when there could still be such a thing. Finney received phone calls from European groups about booking information. He had to explain that RAW couldn't pay them, "but if they were coming through, they'd stop in, and play because they wanted to." In some respects, RAW performances resembled the later Fast/Forward series at the Virginia Museum of Fine Arts, but much less formal and for just two dollars a head, or free.

Out of this mix of improvisation, regional groups were spawned or influenced, such as Idio Savant and the Orthotonics. That spirit of antic

humor and social concern is present today in the Ululating Mummies, Rattlemouth and even the Indigenous Gourd Orchestra.

By 1982, RAW's energies began running down as members dispersed into life and careers. The social environment changed and the general artistic climate chilled. The group voted to disband.

The old Raw-o-grams convey a rambunctious, to-the-barricades enthusiasm. They are typed, handwritten, cartooned and photocopied, and possess a tactile quality that a MySpace page lacks.

A few years separate the two cooperatives of RAW and UAA, but there is a noticeable change in presentation that indicates an intentional difference. UAA's materials are no less passionate, but are designed and printed. UAA was collaborative and spontaneous, but not anarchic. In the "Tour d' Art" program of May 7, 1989, an uncredited writer said, "UAA acts as a support group for artists struggling with both the demands of maintaining gainful employment and sustaining their respective arts."

In 1987, Urban Artists Amalgamated formed with artists sitting ands talking around a kitchen table. Another impetus was the Poor Starving Artists shows in Shafer Court (10,000 Maniacs played there, among other well-known college-circuit bands), orchestrated by UAA cofounder Phil Conein, until the events outgrew his ability to manage them. At that time VCU absorbed the shows.

UAA was deliberate in staying away from acquiring a space. Part of this was a financial decision, but it was also done to achieve the goal of taking the arts out of removed, white-walled spaces and placing it in the city's backdrop of bricks and sidewalks. Alley walls became UAA's gallery spaces. Conein, the poet Falkenstrom, Suzanne Ney, Cheryl Spencer and Robbie Kinter nurtured the fledgling group until they and colleagues opened "An Exploration of the Secret Cityscape" on October 17, 1987, in the Ramcat Alley, which connects the 300 block of Brook Road to Jefferson Street in midtown Richmond.

The day's events, which set the tone for following UAA exhibitions, included a variety of music, poetry readings, hats by Ignatius, improvisational dance and video art. From then on, the traveling "Ramcat Gallery of UAA" exhibited in available urban spaces.

"At the time, alleys were a source for [art] materials," Kinter reflects. "In the '80s, recycled art was popular. We not only used the alleys for making art, but we cleaned them up and showed in them." The commercial activity that had ignited in the Bottom raised rents and sent artists into downtown, to the Masonic Temple, the Richmond Dairy building, scattered through Broad Street and Jackson Ward and the East End neighborhood of Fulton Hill.

Membership fluctuated as core members left and newer ones joined, yet several well-received shows were arranged and in May 1988 the mural was painted at the Seventeenth Street end of Walnut Alley.

The most controversial UAA exhibition, "Nice Things By Young People," came in February 1990, at the city's main library on Franklin Street. The collaborative pieces included a dark and antic Rube Goldberg arrangement that included five tripods with baby dolls and bones and a record player with a cable that made the dolls spin around. It resembled the later mismatched playthings of *Toy Story*. Denise Burge's piece included a chair with a cut in its cushion, stuffed with paper that if removed read LUSH. A pendulum device swung of its own gravity. Also displayed was a large group-made book titled *Recommended Reading*, made of artworks on canvas.

Head librarian Robert N. Costa wasn't impressed and wanted the exhibit removed. Kinter called the American Civil Liberties Union and its representative described the show as "whimsical." Media, sending an arts brouhaha, descended. Costa then said the work could stay, if changes were made. The pendulum was restrained by wire. The stuffed chair was removed by the fire marshal. Burge, amused and still incredulous, says, "So, in this building full of books, magazines and paper, this chair was taken away."

After this high point UAA's collectivist spirit began to wane. There was still time for one more serious show, 1991's "War Pieces" at the Exile Gallery, relating to the Persian Gulf War. In November of that year, UAA contributed to the Richmond For Life celebration before returning once again to Walnut Alley.

Kevin Kravitz, a photographer and artist, felt at home with the group. "But the last six months got really weird. We spent a deal of time deciding who'd lead the group. We had potluck dinners, and these big discussions. It was almost like the Algonquin Roundtable, or the Bloomsbury Group," he laughs. "At least, we thought so at the time."

By the late spring of 1992, UAA had $350 in its bank account and voted to lay the organization to rest, going out the way it came in, with everyone in agreement. The remaining cash was used to hold a farewell party.

Burge is now an assistant professor of art at the University of Cincinnati. Galleries are closing there and art is in trouble. "People are asking, 'What can we do?' And, grounded in my UAA experience, I say, 'Let's go out there and make it happen.'" Falkenstrom, an arts administrator in Tucson, Arizona, remembers UAA as a group of extraordinary people.

"I hope somebody [in Richmond] is leading a ragtag band of scurvy artists through the streets," she says.

Originally published December 1996/April 2007.

RAW and UAA

Update: The Main Street Grill gave way in 2004 to the cosmopolitan Café Gutenberg and the Farmers Market mural is gone, but the Walnut Alley painting, though fading, remains. Richmond sustains a robust gallery and arts scene. Near the Ramcat Alley, in the antebellum Steamer Company #5 building, a hot performance and exhibition space at 200 West Marshall Street works to redefine the city's cultural life.

The Cha Cha Palace
New Wave in an Old Bank

All that's left, really, of the Cha Cha Palace, is a stain. The Magellanic cloud of blotchiness on the heart-pine floor of the mezzanine-level offices at Main Street Productions isn't Confederate blood, but water. "This is where the bar was," indicates Lynn Hale, director of human resources. The firm adapted the building at 1300 West Main Street for film and animation production.

Before it housed either a dance club or a production company, the building served as a bank. First it was the West End Bank of Richmond, then the Depression-era American Bank and Trust Company. After that institution failed, a portion of the building became the sewing room for the federal Works Project Administration (WPA). Thereafter, for almost three decades, 1300 housed the headquarters of the North America Assurance Association.

The space is bright and lit by Palladian windows. A large, arched stained-glass treatment dominates the front of the building. Girding the mezzanine is an iron railing, detailed by a simple deco design of a circle fit into a square.

"You could walk up and peer over the front entrance," remembers graphic designer Doug Dobey. "On the second floor, coats were always piled up because it was hot as hell in the Cha all the time; the place was packed. It would get so hot that the walls would sweat."

"There was a scene, then," photographer Cindy Hicks recalls. Hicks, now with the Martin Agency, followed Richmond music closely. "I was a photographer and bands always need pictures, and I liked the bands, so it was mutual. But it was about lookin' cool; it was about good leather, good hair, just the right kick boots, just the right chains."

New York–based animator Frank Gresham came out of the Chesterfield suburbs into Virginia Commonwealth University and the Cha. From

The Cha Cha Palace

Members of the Dads romp at the Cha Cha Palace in December 1981; *on couch in foreground*, Bryan Harvey; *blonde in center*, David Ayres, Ricky Tubb and Mark Lewis. *Courtesy of Cindy Hicks.*

Gresham's perspective, the club was ahead of the diversity curve. "It was a great place to dance, very forgiving in terms of anybody who showed up was welcome. Nobody cared about your clothing, your sexual orientation, your haircut. I was going through my punk phase."

The Cha began at 705 West Broad Street, in a boarded-up storefront with the name spelled in tinfoil. When the club moved to Main, VCU's art and music crowd discovered it. Open High School students sometimes rented the space for parties.

Kimberly Reese went there as a teenager with several other young women. "We never drank; that wasn't why we went," Reese says. "We all just went together, tried to get there every weekend. It was a great place to dance, a very eclectic crowd—gay, straight, lesbian, hard-core punks, everybody got along."

Jennifer Bell Dillon remarks, "The music scene was just getting started here. It was fresh, a tight clique of people who went out and saw everything. It isn't as diverse now since [the music audience] split different ways. I remember we used to go see *The Rocky Horror Picture Show*, which played forever at the Biograph, then go in costume to the Cha."

Dillon laughs, "We were all probably too young to be there in the first place. I was just a little kid being shocked by it all. It was fun; made you feel like a real insider. It was Richmond's Studio 54."

The Cha had its own version of floor shows. Dirt Woman (Donnie Corker) and hard-core musician Dickie Disgusting (Frank Hutton) wrestled each other either in mud or Jell-O. Sculpture student Dale Vanderhayden partnered with Gresham for unique fashion shows. Vanderhayden created elaborate costumes, buying vintage clothes and then attaching Barbie dolls to them.

Bands that played included the venerable Good Guys, Single Bullet Theory, The Rage, The Dads, the all-woman Laughing Feet, Degenerate Blind Boys, Toronados, Mod Subs, Barbi and the Beeftones and Ten Ten.

The best entertainment at the Cha, though, seems to have been its clientele. This included VCU instructors, disco refugees and late-night movie magnate Ray Bentley. His chauffeur-driven limousine sometimes deposited Cha revelers at their respective homes.

The Heeke sisters, whose emphatic dancing and looks were described as stunning and mysterious, are well remembered. One of Claire Heeke's significant recollections is a dance partner flipping her over to David Bowie's "Scary Monsters" on the illuminated, multi-colored floor.

"I was like, sixteen, and nobody was carding at the door," she says. "It all had a profound effect on me. I'd been going to Catholic schools, there was this whole new world, a fairly intelligent bunch, interested in a diverse range of things. They weren't toeing the line."

Gresham, who has supervised animation components for MTV and Nickelodeon animated series, is thankful he made good friends who shared his initial journey into art and music. "I've been in New York for fifteen years and been in clubs that make the Cha look like Sunday school, but it was where this buttoned-up suburban kid experienced these aspects of life for the first time. Man, it was great."

Originally published October 1998.

Update: The month this piece appeared, Main Street Productions changed its name to Main Street Video and Animation. In September 2002 the company merged with the Richmond production house Park Group and vacated the 1300 West Main Street offices.

One Against the Current
Newton Ancarrow, Pioneer Conservationist

He died in 1991 thinking himself a failure. Pioneer James River conservationist Newton Ancarrow didn't realize the extent of his success. "He thought he'd lost," says his son, Hopper Ancarrow.

Newton Ancarrow, who began his professional life as a chemical scientist, later switched careers and became a master boat builder, starting his own company, Ancarrow Marine, which built $29,000 apiece high-speed runabouts for rich jetsetters such as shipping tycoon Aristotle Onassis and the sheik of Qatar.

Ancarrow's late 1950s and early 1960s boatbuilding informed him of the James River's deplorable condition. He in public compared it to "the Ganges River at Banaras in India."

In 1969, Ancarrow cofounded Reclaim the James Inc., and he advocated the construction of a floodwall to protect the city's water filtration plant. The Virginia Wildlife Foundation, among others, celebrated Ancarrow's work. Yet, throughout the 1970s, Ancarrow was considered an annoyance by government and corporate officials.

The city exhibited further meanspiritedness in 1975 by condemning Ancarrow's marina. It was located across from Rocketts Landing, where Eagle Cruises yachts berth today. This is Ancarrow's Landing, which some in Richmond think is named for a ship captain from centuries ago.

Richmond was making way for an expansion to the water treatment plant that, in the end, was never built. Perhaps it wasn't supposed to be. Ancarrow received no compensation for his improvements. After all, city officials reasoned, who would want to buy a boat dock in such poisonous waters?

The U.S. Supreme Court in 1979 waived the case Ancarrow brought against the Environmental Protection Agency (among other

James River conservationist Newton Ancarrow with lady's slippers, among the wildflowers he preserved in photographs and worked to save in the wild. *Courtesy of Mr. N. Hopper Ancarrow Jr.*

organizations) for their failure to control pollution on the James. Ancarrow then retreated with his ailing wife, Josephine, to their James River Golf Course home.

The court fight began with his boats.

Ancarrow Marine's best seller was the twenty-five-foot Aquilifer, powered by twin three-hundred-horsepower Cadillac engines that reached sixty miles per hour. Among his clients were King Paul of Greece and the emirs of Kuwait and Bahrain. *Newsweek* and *Sports Illustrated* praised the boats as the best of their kind in the country.

In 1961, Ancarrow purchased several acres near the Richmond sewage plant on the James's south bank for boat launching. He once stood with the visiting finance minister of Saudi Arabia watching the trash-laden waters. Ancarrow asked the official what would happen in his country if somebody allowed a river to become this foul. The finance minister replied, "We would cut off his head."

Ancarrow wanted officials to see the river after heavy rains released millions of gallons of raw sewage into the James. Ancarrow observed struggling masses of eels and catfish at this dock, trying to escape. He would observe them "with the skin digested off them."

One Against the Current

Ancarrow testified about the river's health to an apathetic city council around 1966. He brought a large jar filled with putrid water, in which floated a condom and a dead rat. Council dismissed his evidence.

He then produced a powerful, prescient documentary film called *The Raging James*, shot from helicopters, boats and on shore. It aired on public television station WCVE, and Ancarrow showed it to anyone who would watch. Views of waste pouring into the James forced Richmond and the State Water Control Board to take measures against river pollution.

Ancarrow's interest in preserving wildflowers along the James made him an expert photographer. His pictures illustrated David P. Ryan's book, *The Falls of the James*.

Ancarrow's grandson, Grant, owns a restored twenty-five-foot Ancarrow Marine runabout and works for Virginia Semiconductor, where he observes water quality taken into and pumped from semiconductor plants. "The water we send out is cleaner than what went in," he says, "and the company doesn't do it out of niceness. It's the law. My grandfather helped make that happen."

The James River wildlife for which Ancarrow predicted extinction has instead prospered. His beloved wildflowers, though, have taken a beating—primarily from collectors who think in some strange way that they're saving a plant by removing it.

Ralph White, director of the James River Park System, inherited Ancarrow's legacy. They met several times. "People said Newton Ancarrow was absurd, but he wasn't," says White. "He staunchly defended the river, and this city owes him a tremendous debt. He deserves to be memorialized."

The annual James River Park Day in June features tours of Belle Isle, the floodwall and other river-related activities. But you don't need a special time to enjoy the James River parks. The forests and rolling river are there for your pleasure whenever you desire to seek them out. That is Newton Ancarrow's monument.

Originally published June 2003.

Fulton School
Gus and Lynn Garber Brought Life to Old Halls

Since its 1916 completion by Carneal and Johnston, the columned Robert S. Fulton School has stood high upon a majestic East End hill as a temple for education, a symbol of how learning can lift one up and how attaining knowledge sometimes requires a tough climb.

The school provided instruction for kindergarten through seventh grade. Generations of students from the surrounding Fulton neighborhoods clambered up the steep steps—including Gottwalds of Ethyl Corporation renown and Garbers, who gave to Richmond a mayor, administrators and business people.

The Fulton School closed in 1975. By then, most of the neighborhood it served was torn down. The old Fulton community, spread in the valley between Chimborazo and Powhatan hills, got caught in cycles of development and bureaucratic wrangling. The predicament stalled improvements and rolled "urban renewal" bulldozers over churches, shops, houses and civic objections.

Then, in 1981, Gus Garber retired from the family door business. He and his wife Lynn, both incapable of sitting still, fixed upon their next project: saving a piece of community history, the Fulton School. Gus first wanted it refurbished for business.

Daughter Marion Garber recalls that a standard commercial application wasn't viable. "Mother was the one who had the idea about bringing in artists. He was originally opposed to it. But once [the artists] started coming, Daddy fully committed himself."

Artistic expression wasn't alien to either of them. Lynn painted, as did her brother W. Stanton Forbes. She exhibited at the Virginia Museum. Paintings of their mother's sister, Lucy May Stanton, are displayed at New York's Metropolitan Museum of Art and the Smithsonian. Gus's mother,

Fulton School

Painters Donald Crow and Amie Oliver in front of the Fulton School, circa 1989. Don was one of the original painters who set up a studio on the hill and maintains one there today. *Courtesy of Amie Oliver.*

Anna Nelsen Garber, possessed a strong contralto voice and performed on WRVA. Fulton alums recall Gus playing piano remarkably well and hearing his voice echoing in the school's spacious halls.

In 1982, collage and assemblage-maker John Morgan needed a studio. He heard about the Fulton School from Dr. Hugh Sutherland, also Lynn's physician. "I went over there and talked with Gus and he said, 'A handshake's good enough for me.' I was there for three and a half years."

Morgan instructed at the Virginia Museum. He suggested to student Lauri Luck that she make use of an old classroom. Luck, now living in San Francisco, considers it the best studio space she's ever known, although it did require a massive cleaning job. One August afternoon, soon after finishing her chore, Luck turned to see a man's face in the window. "We both screamed," she laughs. "It was a fireman from the station across the street. I honestly thought 'Oh, God, the place is burning and I just mopped!' The firefighters were just using the school for ladder practice."

During a late evening stroll around the grounds, Morgan, Luck and artist Anne Martin gazed up at a purple star hung in the apex portico roof. Gus and Lynn came by. Luck asked the meaning of the star. Gus replied, "We're hoping three wise men will come and tell us what to do with the building."

Donna Weiss Nicholson came to the school and Room 103 in 1984. "The ambiance of the place, the sense of it, enormous canvas stretchers leaning against the walls, the dust motes dancing in the air, the sounds, the echoing. It was magical," Nicholson says.

When the Ululating Mummies began rehearsing in the basement, Nicholson discovered that her sink pipe passed into their chamber. "When

they played, it came right up," she says. "I literally had piped-in music." Other bands followed, including the appropriately named Theories of the Old School, featuring Maggie Freund, Eileen Edmonds and Adam Schaffer.

In 1988 artist Amie Oliver, who was then teaching at Longwood College in Farmville, Virginia, wanted a place removed from an academic setting in which to create. "I'd been looking for a new studio space for quite a while," she recalls. "A friend directed me to a huge old brick school house on a hill. I walked in and the entire building emanated the sweet smell of drying oil paint. It was a dream come true! I didn't think it was possible to find a collective studio in Richmond so close to what I'd seen in Europe. It is definitely one of the reasons I am still living in Richmond."

Mugsy Lunsford began attending contract movement improvisational sessions in 1989. The group claimed a large room at one end of the main hall. They made no changes. "The blackboards were up, the windows were creaky and we polished the floor with our bodies."

The school had celebrations and gallery tours, security microphones that caused everyone to say hello and goodbye to Gus and the school, and performances like the 1988 room-by-room progressive Christmas play for children put together by actor Bridget Gethins. In 1889, the Goddess of Democracy, destined for D.C. and fashioned in part by Greig Leach and VCU sculptors in solidarity with the students of Tiananmen Square, landed in Fulton. There also were film shoots and a roster of artists including Don Crow, Louis Poole, Beasey Bogan and Rita MacNelly, Larry Mullins, Andras Bality, Mary Scurlock and Kelly Gottschalk. Some made the Fulton Hill neighborhood their home.

But Lynn and Gus were mortal. After Lynn's death, Gus kept himself occupied by sculpting a fallen tree in the school's front yard into a giant clothespin. Gus died in 1992. The school remained studios in family trust until late 1997. Longtime Fultonite Maggie Freund and a partnership purchased and refurbished the school for studios and assemblies.

"All we can do is try to keep the spirit of Gus's memory," Freund says. "He was a great conversationalist, a dapper dresser. He had a magnificent laugh and he was a great friend."

The three wise men never arrived, although a Buddhist teacher and Senegalese drummers have visited the renovated building. Maybe somebody saw that purple star, after all.

Originally published September 1998.

Update: The renovated Fulton School's halls remain active, with both artists and commercial endeavors.

Shipwrecked
Pleasure Island and El Toro

G ather around and listen to the tales of two vessels good and true, the *Pleasure Island* and *El Toro*.

The first was built in 1890 by the United States Navy as a barge that would have been towed as a floating machine shop, according to newspaper articles. In May 1950, the two-decked *Pleasure Island* came into Colonial Beach "gaily decked with bunting and loaded with one-armed bandits and whiskey," Joan Baker wrote in 1952.

The one-hundred-foot-long, twenty-foot-wide vessel anchored just beyond the low water mark on the Potomac River on the Maryland-Virginia state line. It operated as a legal gambling ship under Maryland's jurisdiction and avoided Virginia's restrictions on liquor and games of chance. *Pleasure Island* in that incarnation could carry 250 people. A red leather bar set against mirror walls dispensed refreshment to thirsty gamblers.

When Richmond Police Lieutenant Charles Brockwell purchased the *Pleasure Island* for less than $5,000 in June 1952, it had lain idle for more than a year. Brockwell's intention was to convert the craft into a houseboat in which he and his wife could travel during their retirement. He planned to dispose of two hundred kapok and cork life preservers, twenty-six steel chairs, a thirty-foot launch (used as a taxi boat for patrons), a one-thousand-pound anchor and chains, a bell and three rafts.

Brockwell's health didn't allow the realization of his dream. He sold the boat to Henry J. Phillips, son-in-law of Captain Herbert Presson and manager of Captain Herbert's Fresh Seafood Boat, then at Seventeenth and Dock Streets. *Pleasure Island* was first moored at Nineteenth and Dock, and then moved a few blocks up.

In 1967 Gip Dickens purchased the barge. Dickens, once a member of the New York Giants farm system, had traveled throughout the United

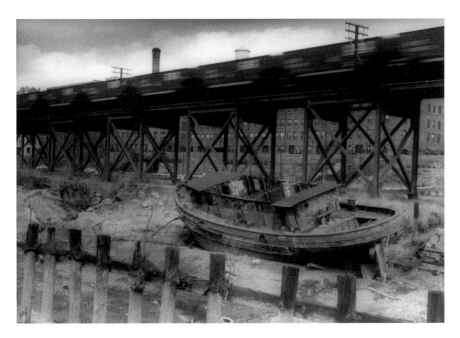

The *El Toro* was left high and dry in the Kanawha Canal after 1970 and became a riverfront curiosity until she was dismantled by torches almost seventy-five years to the day of her launching. *Courtesy of Tim Ashman.*

States and South America playing ball. "I got out of it in '60 because I was thirty-two and getting old for the game," Dickens recalls.

Dickens and partner Joe Pinavelli worked at converting *Pleasure Island* into a sixty-two-seat seafood restaurant. Dickens says *Pleasure Island* did a fair lunchtime trade, and diners remember generous portions. The barge rode out Hurricane Camille but in 1972, during the receding waters in the aftermath of Hurricane Agnes, *Pleasure Island* cracked its hull. Dickens took the name to Colonial Heights, where he opened a successful seafood restaurant on dry land.

The tug *El Toro* was launched on March 10, 1924, at the New Jersey Drydock & Transportation Co. of Elizabethport, New Jersey. The riveted steel-hulled boat was ninety-six feet long and twenty-three feet wide and powered by a vertical compound reciprocating steam engine. She carried a crew of seven. From 1924 to 1941, *El Toro* was owned and operated by the Southern Pacific Co. and with a sister boat, *El Rey*, served out of Pier 49 on New York's North River. Their charges were one of nineteen passenger and freighter steamships managed by the Southern Pacific and Morgan lines. These ships traveled to make rail connections on the West Coast.

Shipwrecked

El Toro was sold in 1942 to the Chesapeake & Ohio Railway Co. in Hoboken, New Jersey, for $150,000 and rechristened *Chessie*. She docked coal carriers at the railroad's Newport News piers. She received yet another name in July 1948, that of *W.J. Harahan*, honoring William Johnson Harahan, C&O president from 1920 to 1937. The reliable tug went unused after 1962 and was destined for scrap when, in 1970, Sandston attorney Charles Sydnor bought the *Harahan* in the hope of creating a floating weekend retreat. It was anchored near what are now the Tobacco Row apartments, where the hulk sat rusting.

Sydnor's son, Charles Jr., president of WCVE Public Television, was aware of the boat from his youth but hadn't given it much thought. "My father's health broke in the 1970s, and when he died in 1981, like most lawyers, he didn't have a will. It took us a few years to settle the estate and I knew there was a tugboat somewhere."

The senior Sydnor intended to install a diesel motor. He removed the eighteen-foot-high steam engine and gave it to the Chesapeake Bay Maritime Museum of St. Michaels, Maryland. The museum's curator, Peter Lescher, believes that the tug's deterioration lessens its importance because better examples exist elsewhere, such as a later version at the Baltimore Museum of Industry. "Vessels getting left to sit like that aren't as unusual as you'd think," Lescher says.

Sydnor adds, "It's beyond rehabilitation for seaworthiness, but maybe something could be done in conjunction with all the construction going on along the canal."

Thus ends the tale.

Originally published August 1997.

Update: Almost seventy-five years to the day of *El Toro*'s launching, in March 1999 workers for Dedicated Demolition and Trucking cut into her hull with torches. The vessel was considered in the way of a canal restoration project.

About the Author

Harry Kollatz Jr. is a lifelong resident of Richmond and senior writer for *Richmond Magazine,* which began publishing his "Flashback" column in 1993. He is co-founder and past president of the Firehouse Theatre Project. He lives with his wife and partner-in-art, Amie Oliver, and their two cats. Youthful Flannery drives the already annoyed Siamese Miró crazy.

Please visit us at

www.historypress.net